THE GENIUS OF
FERDINANDO CARULLI

A NEW EDITION OF CARULLI'S 24 PRELUDES,
OPUS 114
EDITED AND ANNOTATED
BY
HARRY GEORGE PELLEGRIN

First Edition Copyright 2015, Harry G. Pellegrin. All rights reserved. No part of this book may be reproduced or transmitted in any form or by any means, electronic or mechanical, including photocopying, recording or by any information storage and retrieval system without express written permission from the publisher.

PAB Entertainment Group
P.O. Box 2369
Scotia, New York 12302
www.pellegrinlowend.com

Printed in the United States of America

THE GENIUS OF FERDINANDO CARULLI

Cover designed by £ Pound Sterling Graphics

Publisher's Note: *All compositions are in the public domain.*

Library of Congress Cataloging-in-Publication data available upon request.

ISBN 978-1-329-42006-9

Pellegrin, Harry George, Genius of Ferdinando Carulli, The

Copyright 2015

Ferdinando Carulli (1770-1841)

Ferdinando Maria Meinrado Francesco Pascale Rosario Carulli, noted pedagogue, authored one of the first complete classical guitar methods, a method that is still in use today. Carulli was born in Naples, Italy on February 9, 1770. His father was the secretary to a delegate of the Neapolitan Government. He received instruction in musical theory by a priest, who was also an amateur musician. Carulli's first instrument was the cello, but when he was twenty he discovered the guitar and devoted his life to the study and advancement of the guitar. As there were no professional guitar teachers in Naples at the time, Carulli developed his own style of playing.

In 1801 Carulli moved to Paris, then the center of musical activity in Europe, and remained there until his death. In Paris Carulli became a very successful musician and teacher. It was there that he published most of his works, eventually becoming a publisher himself and printing the works of other prominent guitarists. Many of the pieces now regarded as Carulli's greatest were initially turned down by the publishers as being too hard for the average player, and it is likely that many masterpieces were lost this way. Undeterred, Carulli started publishing his pieces himself. However, the great majority of Carulli's surviving works are those that were considered 'safe' enough to be accepted by other publishers, mainly for the teaching of certain techniques or for beginners. Although he had many students and supporters, Carulli began to believe he didn't deserve his impressive reputation because most of the great works that he had composed were never published.

Confined to mainly simple pieces, Carulli wrote his method of classical guitar, "*Harmony Applied to the Guitar*", a collection of pieces that are, as written previously, still studied today by students of the instrument. Carulli died in Paris on the 17th of February 1841 at the age of 71 years.

As a young student I was made to read through, study and learn the twenty four preludes of Ferdinando Carulli. It was implied that these preludes were right hand studies and would supplement my work with the Giuliani Opus 1 right hand studies. It was easy for me to see that the Giuliani studies were intended for the simple (!) purpose of disciplining and strengthening the right hand. These Carulli preludes did not seem to cover as much pedagogical ground as the Giuliani 120 Etudes did and I had begun this task with more than a bit of consternation bordering on revolt.

Years later, I began to appreciate that Carulli probably did not merely intend these short pieces to be simple right hand exercises. It is my belief that he actually intended them in the traditional definition of prelude:

> A **prelude** (Germ. *Präludium* or *Vorspiel*; Lat. *praeludium*; Fr. *prélude*; It. *preludio*) is a short piece of music, the form of which may vary from piece to piece. The prelude may be thought of as a preface. While, during the Baroque era, for example, it may have served as an introduction to succeeding movements of a work that were usually longer and more complex, it may also have been a standalone piece of work during the Romantic era. It generally features a small number of rhythmic and melodic motifs that recur through the piece. Stylistically, the prelude is improvisatory in nature. The prelude also may refer to an overture, particularly to those seen in an opera or an oratorio. (Wikipedia)

My understanding regarding the purpose and intent of the earliest preludes was that the performer would improvise a short piece in the key with similar themes and a similar musical flavor to alert the audience that a dance or song was going to start soon and they should stop

talking and get ready for the music! Many preludes are comprised of arpeggios and it has been suggested that the prelude also allowed the performer to check tuning.

I have reproduced the first few Giuliani Right Hand Etudes. Carulli's also start with a simple right hand fingering—one that is easy for the new student though does not *necessarily*

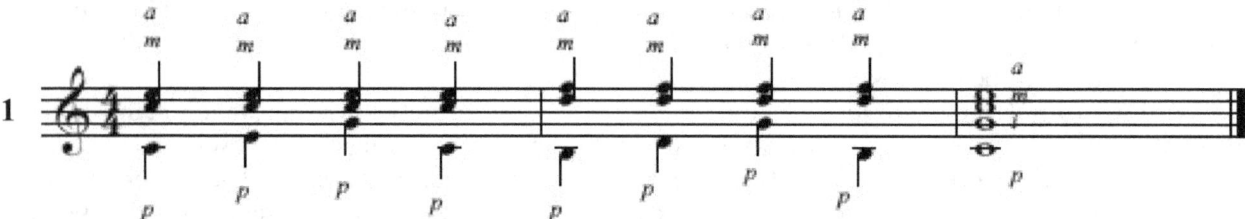

demonstrate good technique. Although the first example here utilizes the *m* and *a*, note that the thumb is extended over to the third string! The basic fingering lists *i* and *m* which is the fingering Carulli uses in his first prelude. Ideal execution of the Giuliani Etude using perfect right-hand home-positioning would result in the following fingering—one that might be difficult for the new student to cleanly execute:

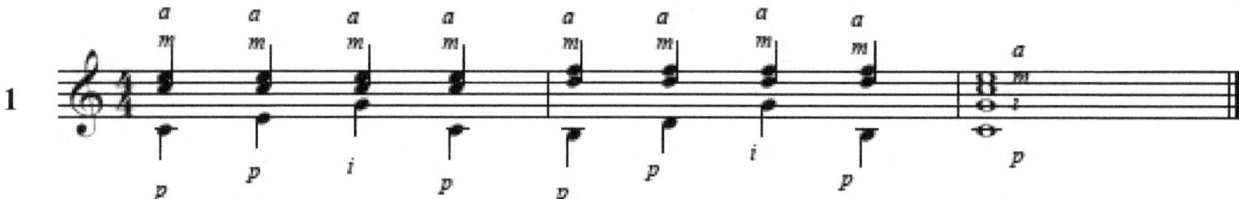

The first arpeggiated permutation of this basic exercise is Giuliani etude two and is reproduced here. It is easy to see that this is the same 'pattern' for the right hand as is found in Carulli Prelude One. The first prelude is indeed an expansion of Mauro Giuliani's second etude. The right hand fingering, although not correct 'home position' play, it is the easiest new student fingering for this type of passage.

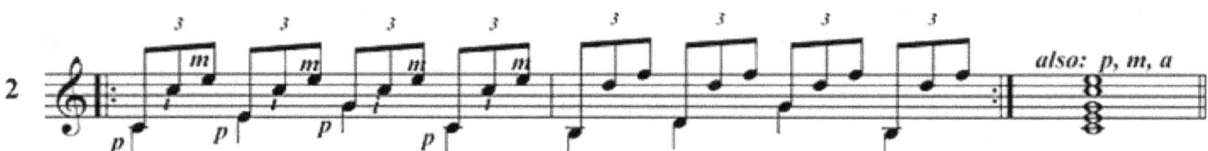

So the question is only partially answered as to what these preludes are intended to accomplish. It is my contention that there may be a double-duty nature to these preludes. Carulli wanted to give his student practical lessons in proper right hand technique but he also wanted them to be slightly less tedious than the repeated harmonic structure inherent to the

Giuliani etudes. Regardless of pedagogical intent (if any) the Carulli preludes begin with simple right hand fingering and progress to what one might consider to be more real-world samples.

Here is a very simple general rule (and probably fraught with contradictory examples in the repertoire): When playing melodic/scale passages, one should use alternating right hand fingering (i.e.: *i, m* or *m, a*, etc.) and for arpeggio selections, one should use **home position** right hand fingering. What is home position? It is a right hand placement that allows the hand to function most efficiently without changing its basic geometry. To accomplish this, each finger is assigned a string, the index finger solely plucks the third string, the middle finger solely plucks the second string and the ring finger solely plucks the first string. The thumb, due to its position on the hand, opposes the fingers and can cover the three bass strings without disturbing the basic geometry of the hand—the thumb can move without displacing the fingers even as they function.

A few basic items to keep in mind: Some arpeggiations contain concurrently plucked intervals within the context of the arpeggio. Remember that by observing home position, adjacent fingers will always play adjacent strings and non-adjacent fingers will always pluck non-adjacent strings. This keeps the finger spacing perfectly even throughout the execution of this type of complex arpeggio. The key is to minimize extraneous motion and reserve stamina.

Prelude One on the following page has two fingerings listed with it. One is *thumb, index, middle* as is seen in the first three Giuliani etudes. A variant would be *thumb, middle* and *ring* repeatedly. This is close but still not correct home position play. Once the prelude can be performed with the two fingerings described above, the student should attempt it in true home position. Measure one will then be *thumb, middle ring, index middle ring*. This is true home position and should at first feel marginally odd, but will be the most natural performance technique in the long run.

The earliest series of preludes include detailed right hand fingerings. As the preludes become more complex, it is assumed the guitarist will 'have a feel' for what the fingering should be; only the most obscure passages will include right-hand fingering. Prelude one also includes some alternate performance suggestions that change both the order as well as the repetition of notes. Fingerings are noted. This practice was introduced to guitarists in Willi Domandl's edition as published by Simrock. I have included modifications to these alternate variations to incorporate both the original right hand fingerings and to act as an inroad to home position play.

The first few preludes are rather simple but still more harmonically complex than the Giuliani studies and are, therefore, more palatable to the student guitarist. Some of the later preludes are actually quite pretty and while the player will never use any for an encore at Carnegie Hall, there is a certain joy that can be gleaned from a clean performance of these short pieces.

So how should the guitarist approach these preludes? The student will find these preludes a good sight-reading workout in the later numbers, say 12 on. Of course, the new student may find Prelude One daunting! The right hand workouts are not as strenuous (through diversity) as the Giuliani etudes are, but these preludes are more 'real world' oriented. The guitarist should be ever mindful of maintaining good home position play in that one doesn't want adjacent fingers on non-adjacent strings. Tone, volume and voicing should be carefully considered.

Carulli's music demonstrates near-perfect voice leading and this sometimes can mislead the new student. The new student likes to see chords in root position and Carulli often uses inverted chords (chords with the third or the fifth in the bass voice.) Reading through these preludes can be an education in voice leading and inverted chord recognition.

Prelude No. 1

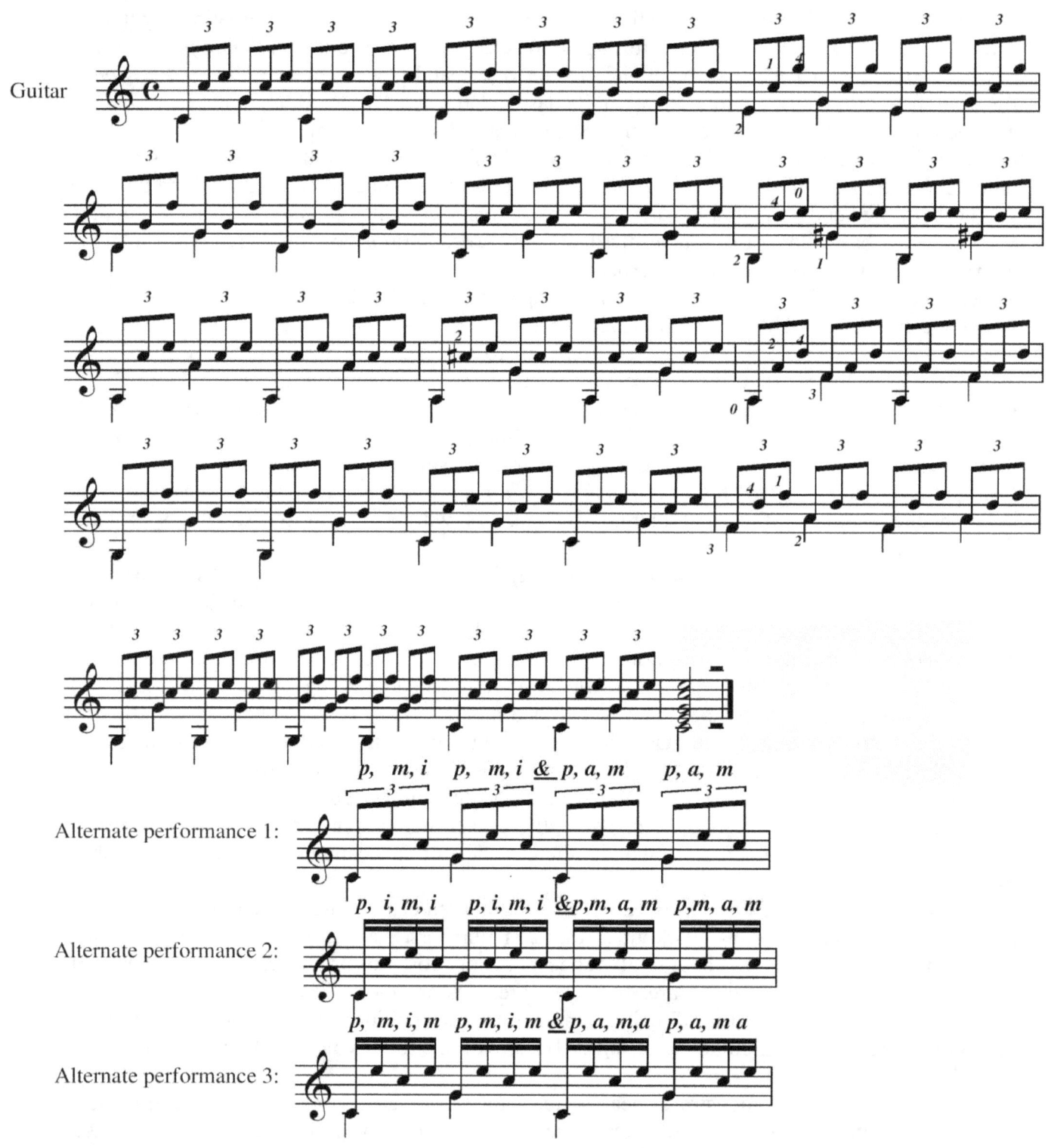

Prelude No. 2

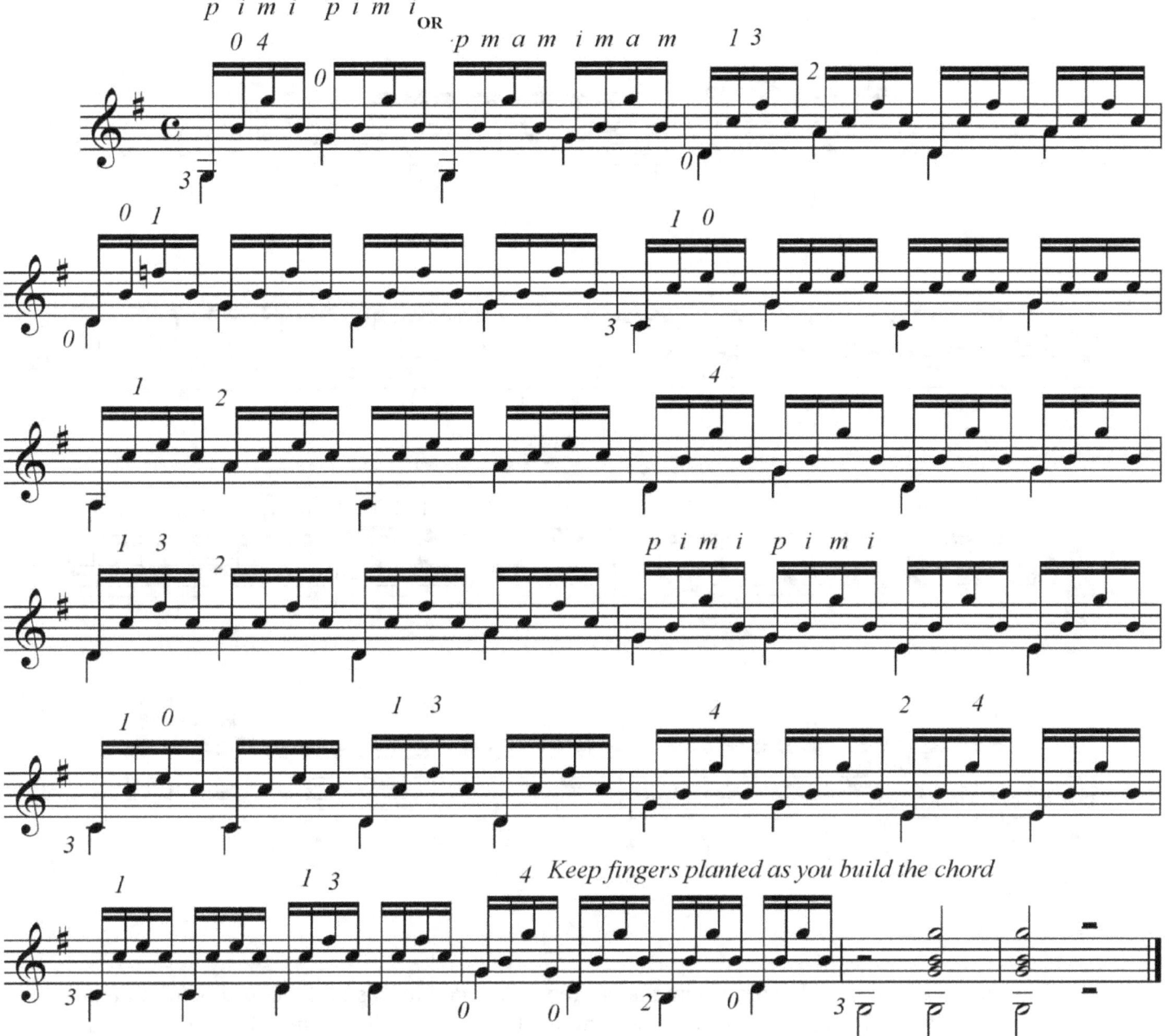

Compare this prelude with Giuliani's 81st Etude. I would recommend the student begin with a ***p, i, m, i*** fingering but also to practice the prelude using ***p, m, a, m***. Best right hand fingering practice dictates that non-adjacent fingers should be used to pluck non-adjacent strings in arpeggio passages. The thumb is the exception to the rule as its mobility is quite different than the fingers and can cover three strings (and bypass strings without destroying hand geometry and placement. Note inscription over final three measures. The left hand fingers should remain on notes as they are fretted in the thirds from last measure--which completely prepares for the chords in the last two measures.

Prelude No. 3

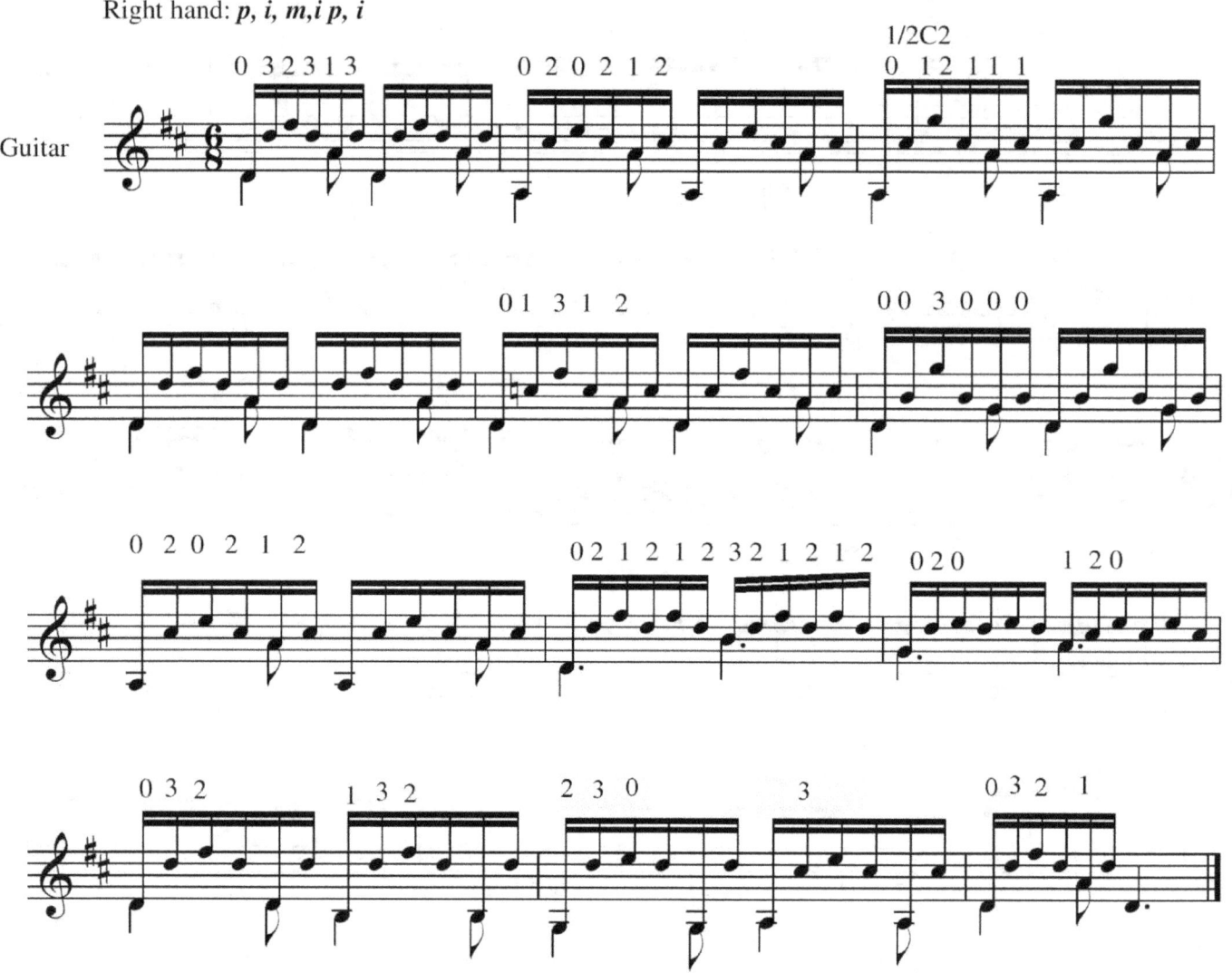

Home position right hand fingering is not recommended in this prelude as this might tend to obscure the bass voice in measures eight and nine. The thumb is better suited to this task than the index finger. These first three preludes are rather simple in nature and many new students will quickly read through and discard Preludes 2 and 3 as they are rather short and seemingly trite. May it then be recommended that they be used as warm-up exercises after they are satisfactorily completed?

Prelude No. 4

Right hand: *p, i, m, a*

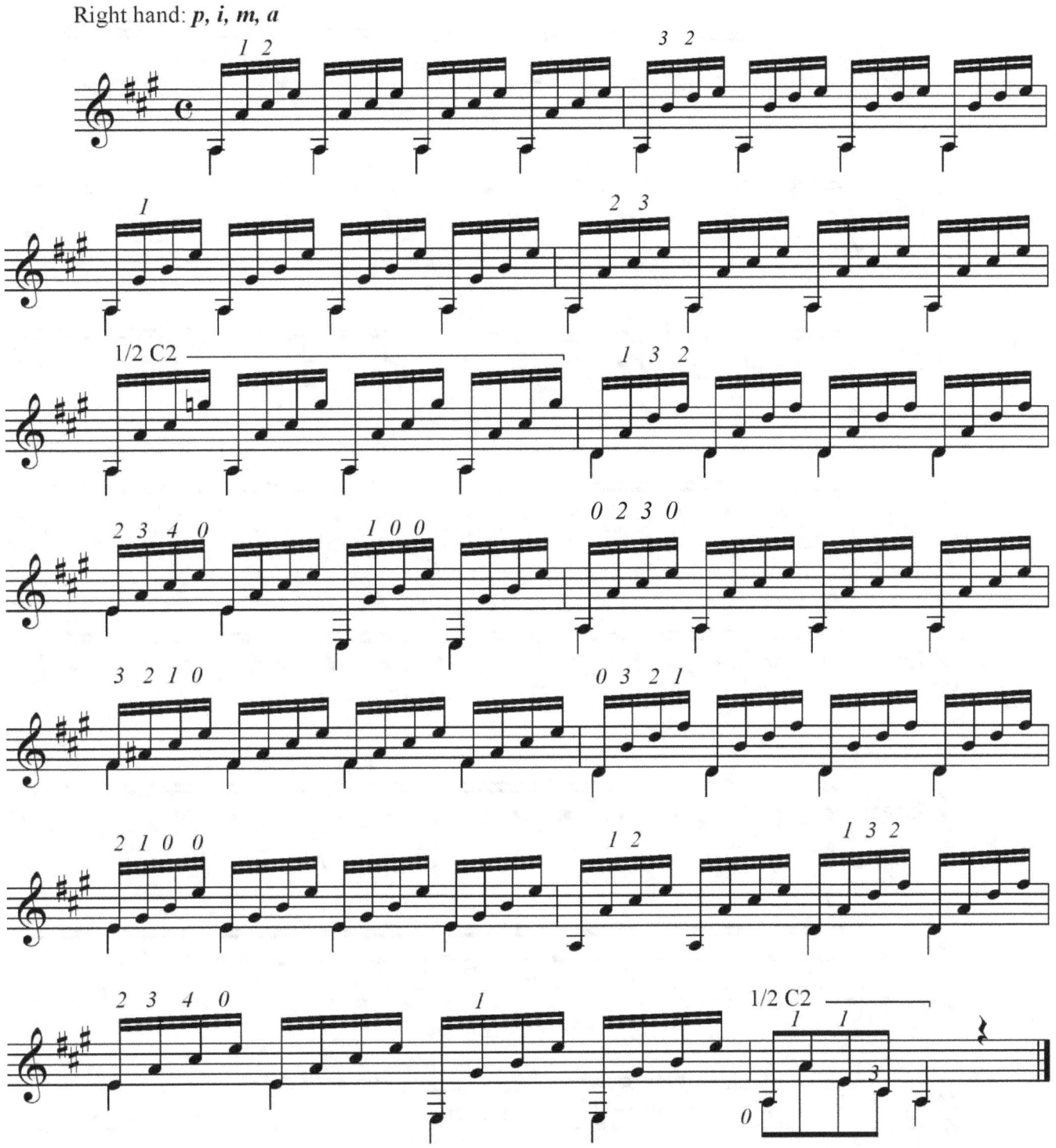

Pedal point bass line: A pedal point is a repeating note in the bass line that is so called due to the use of this figure on the organ (it's easier to prolong a note on the pedals with one's feet.) Here it is very effective in maintaining flow and increases harmonic tension without destroying the underlying harmonies in the first five measures

Prelude No. 5

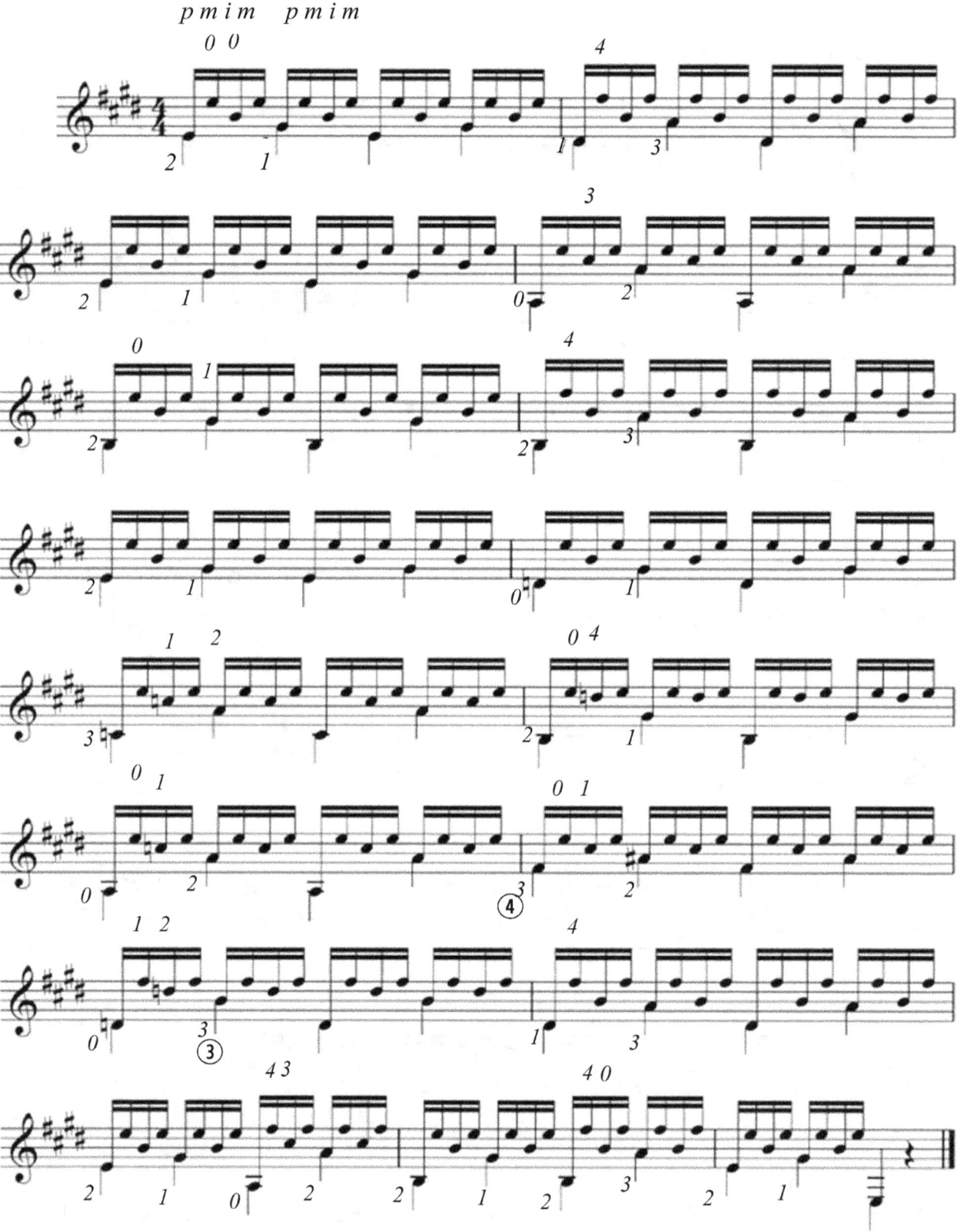

Prelude No. 6

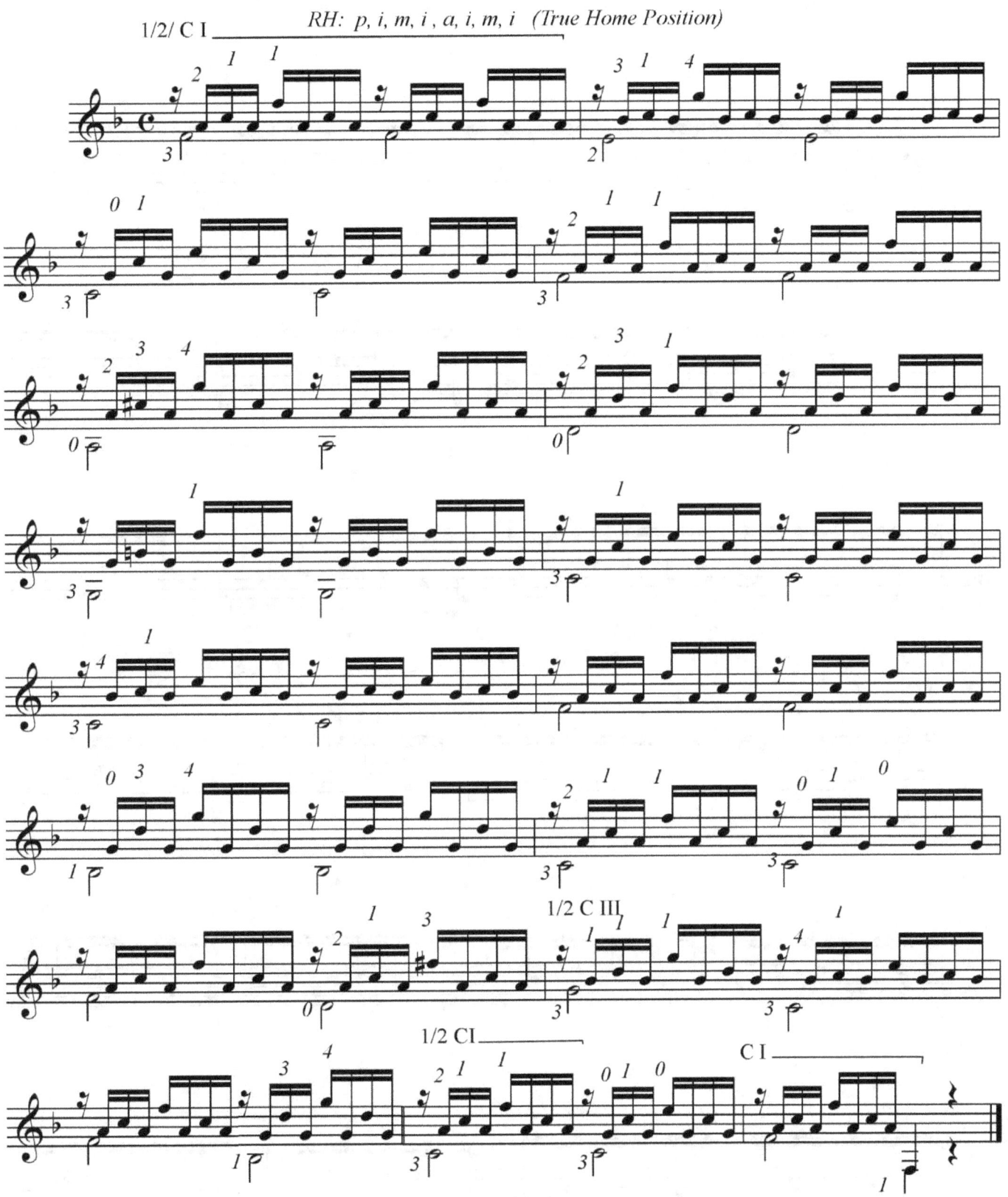

Prelude No. 7

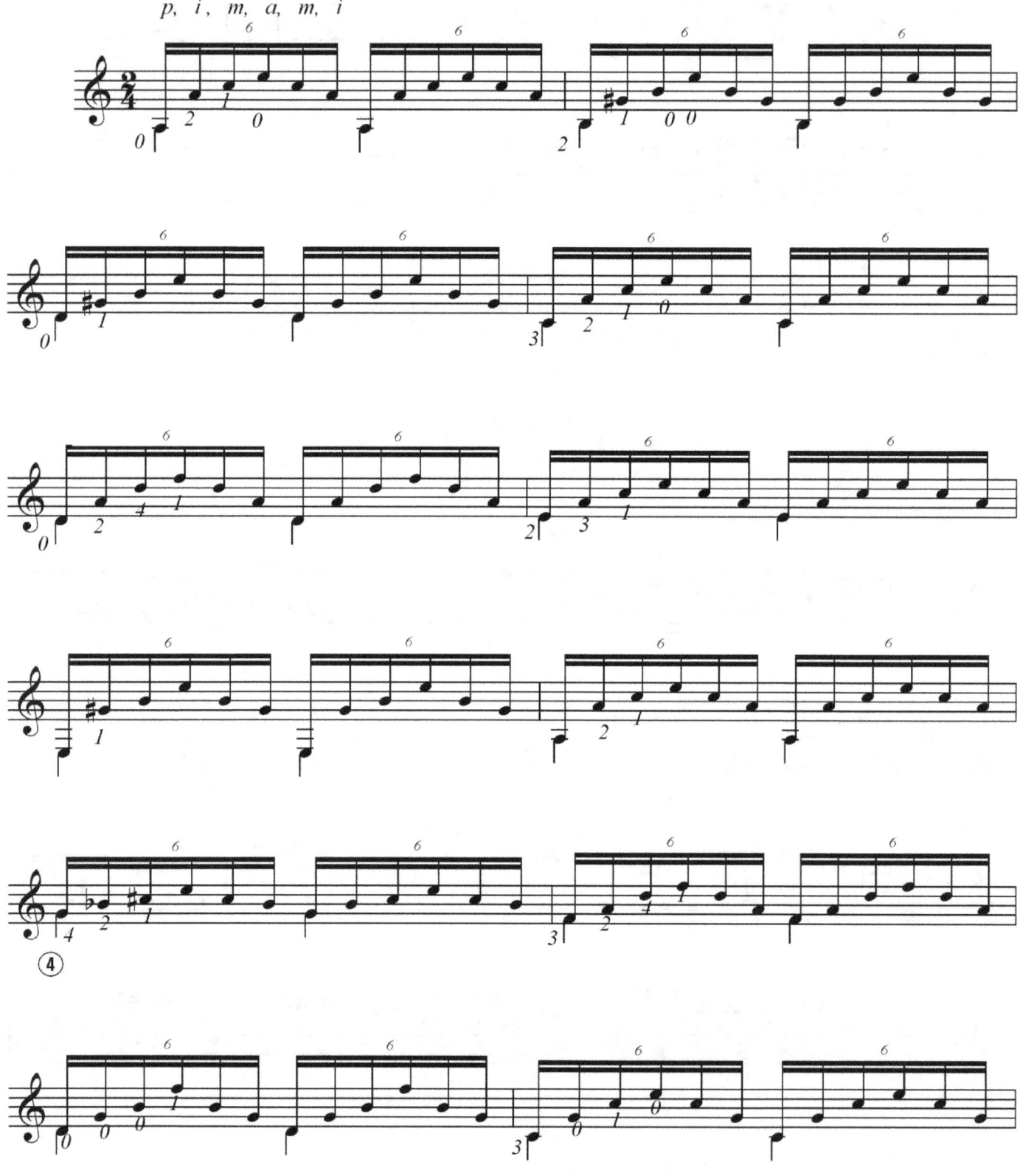

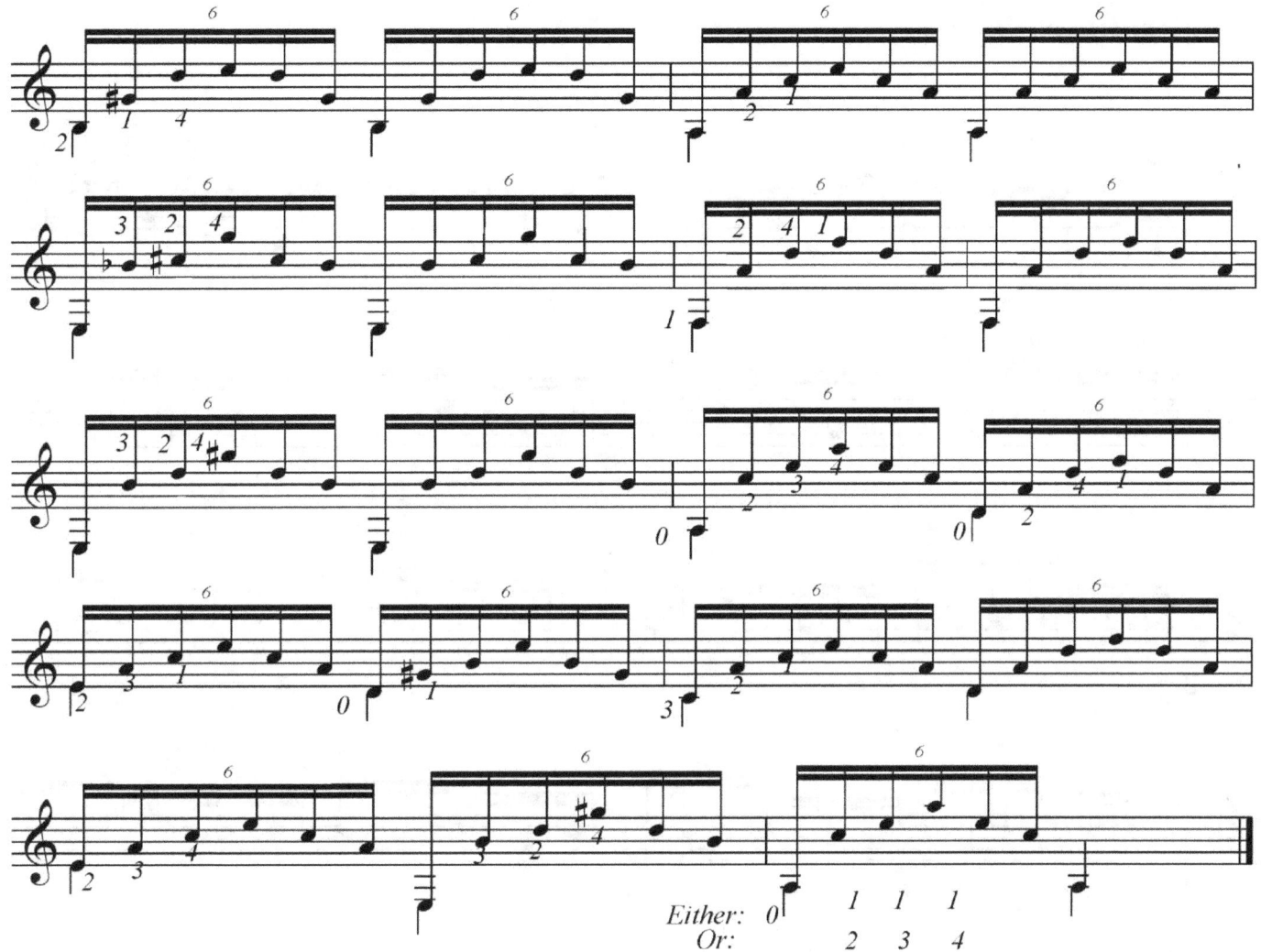

Prelude 7 teaches the new student a rhythmic concept as well as a right hand pattern. The music clearly demonstrates sextuplet notation and is in 2/4 time, yet many new students perform this prelude as if it is comprised of triplets played in 4/4. Be sure the "and" beats are not accented! Accenting beats one and two should guarantee proper performance of the sextuplets. The *one finger after the other finger* nature of the right hand plucking make this an excellent cool-down exercise after more complex right hand patterns have been practiced.

Prelude No. 8

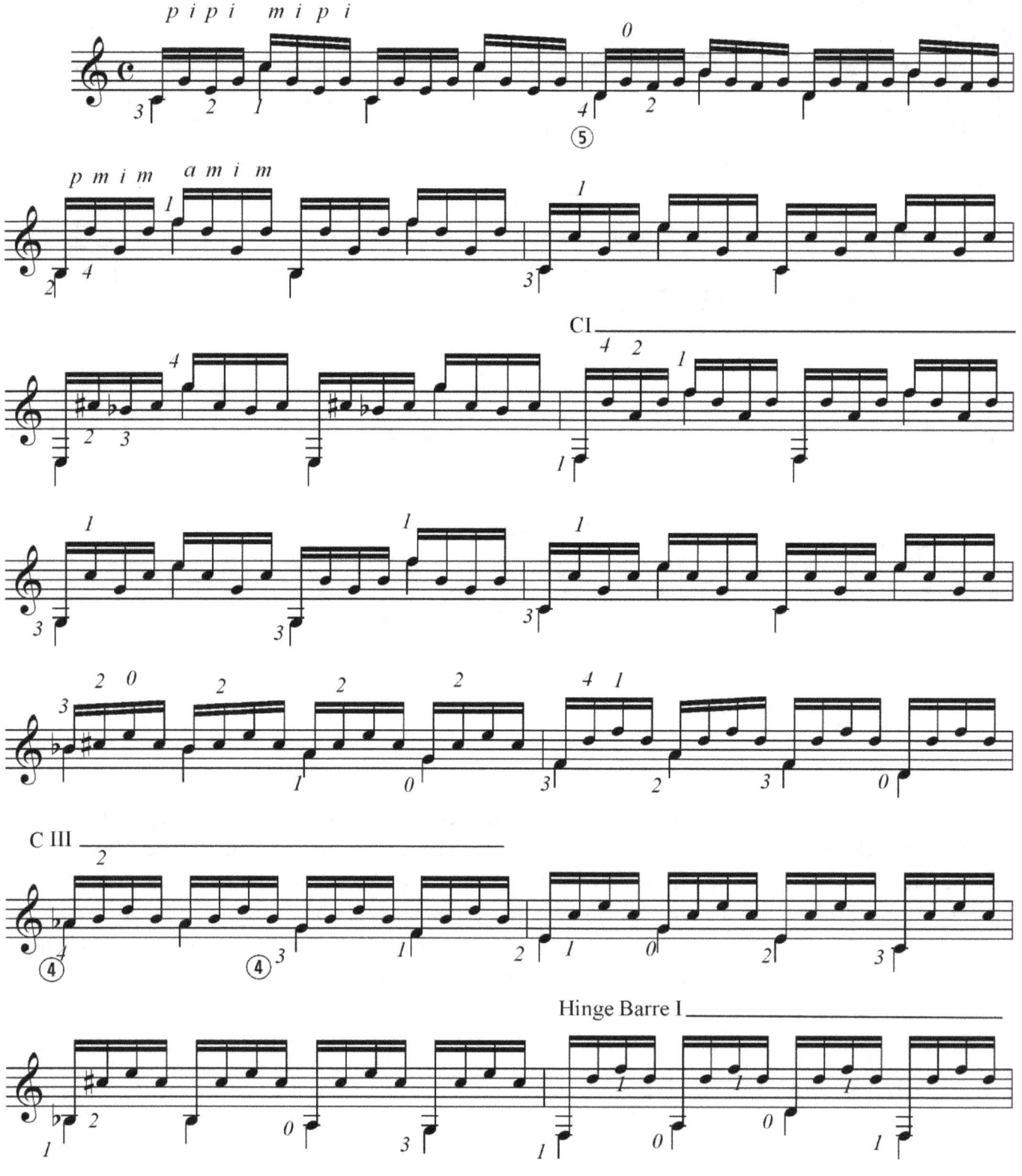

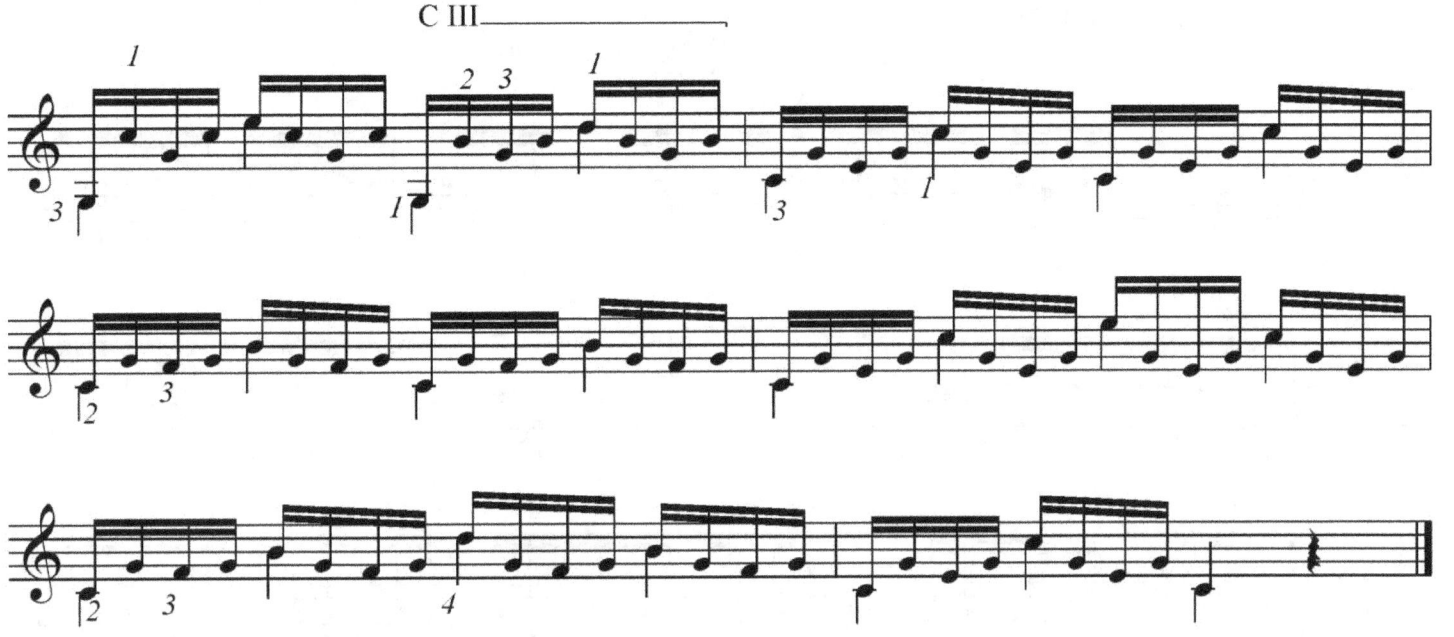

Some thoughts on Prelude Number Nine

The first two measures of Carulli's Opus 114 Number 9 are fingered as illustrated in at least one popular edition as indicated in the top line of the following musical example:

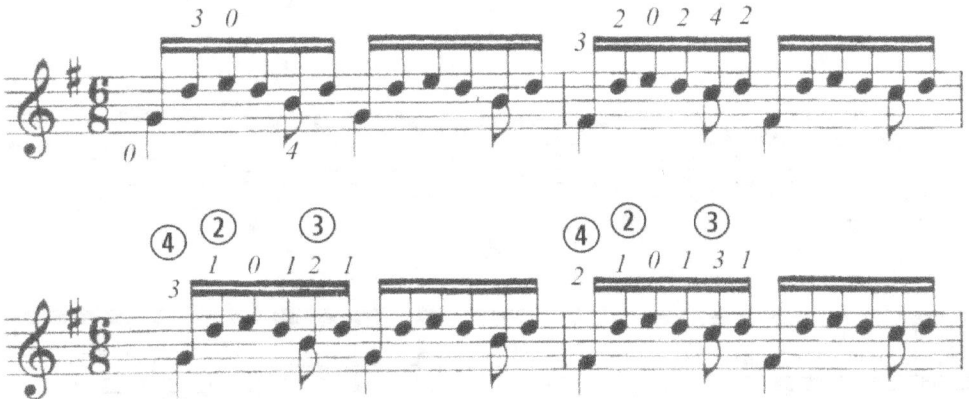

The fourth finger must fret the note 'b' and then release to allow the open g string to be sounded. This wagging finger is an unnecessary disruption to the flow of the arpeggio. The repeated fretting and releasing of a note to facilitate the sounding of an open string wastes time, energy and in some instances can lead to fretting inaccuracies. At best this type of fingering impedes any possibility of producing a legato effect such as allowing the open string (as well as the note being fretted) to ring *slightly* past its duration. By simply re-fingering as shown in the second line, left hand motion flows better and is more progressive in nature.

Prelude No. 9

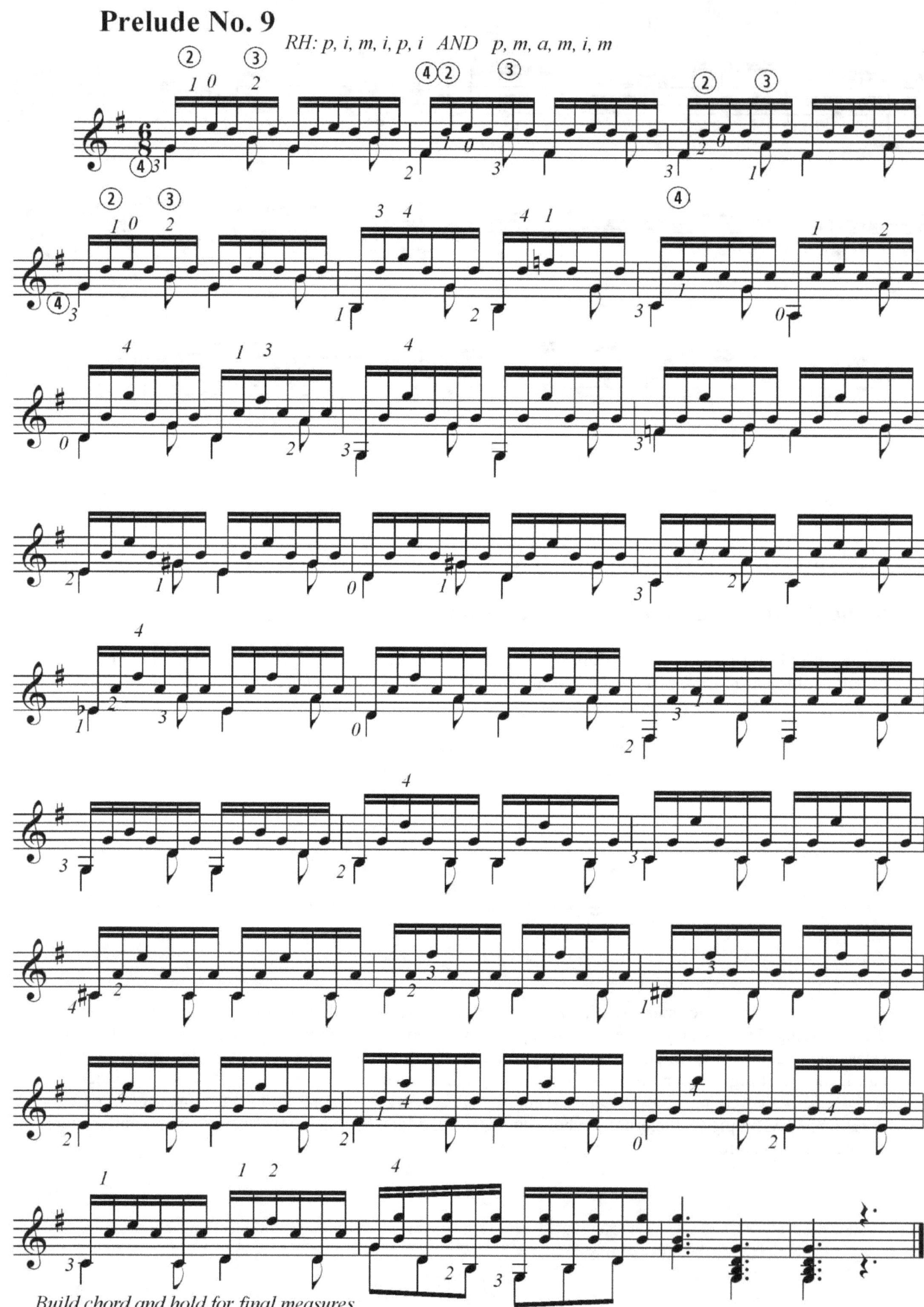

Build chord and hold for final measures.

Prelude No. 10

Right hand: *m i m i & a m a m*
p p p p

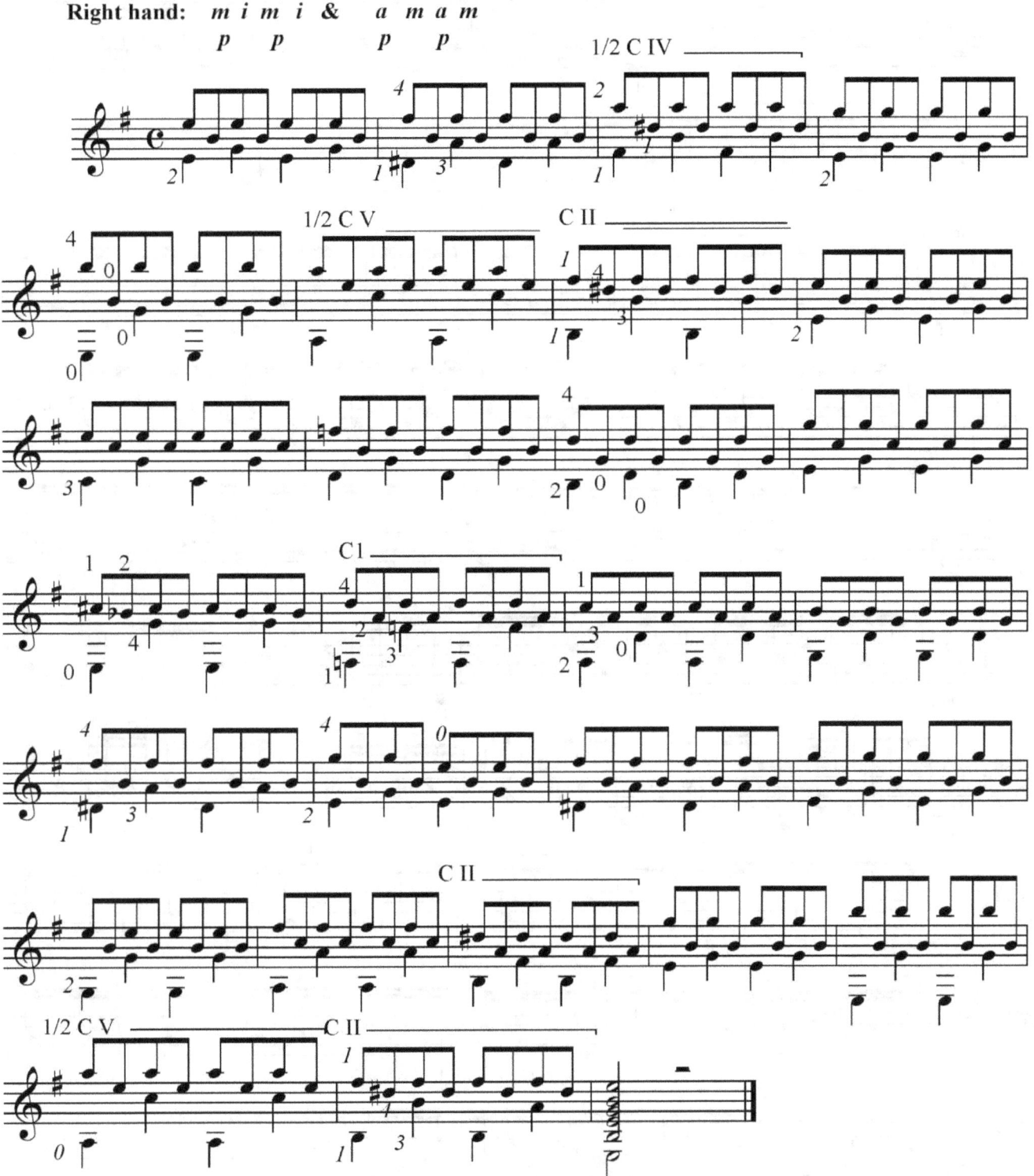

Prelude No. 11

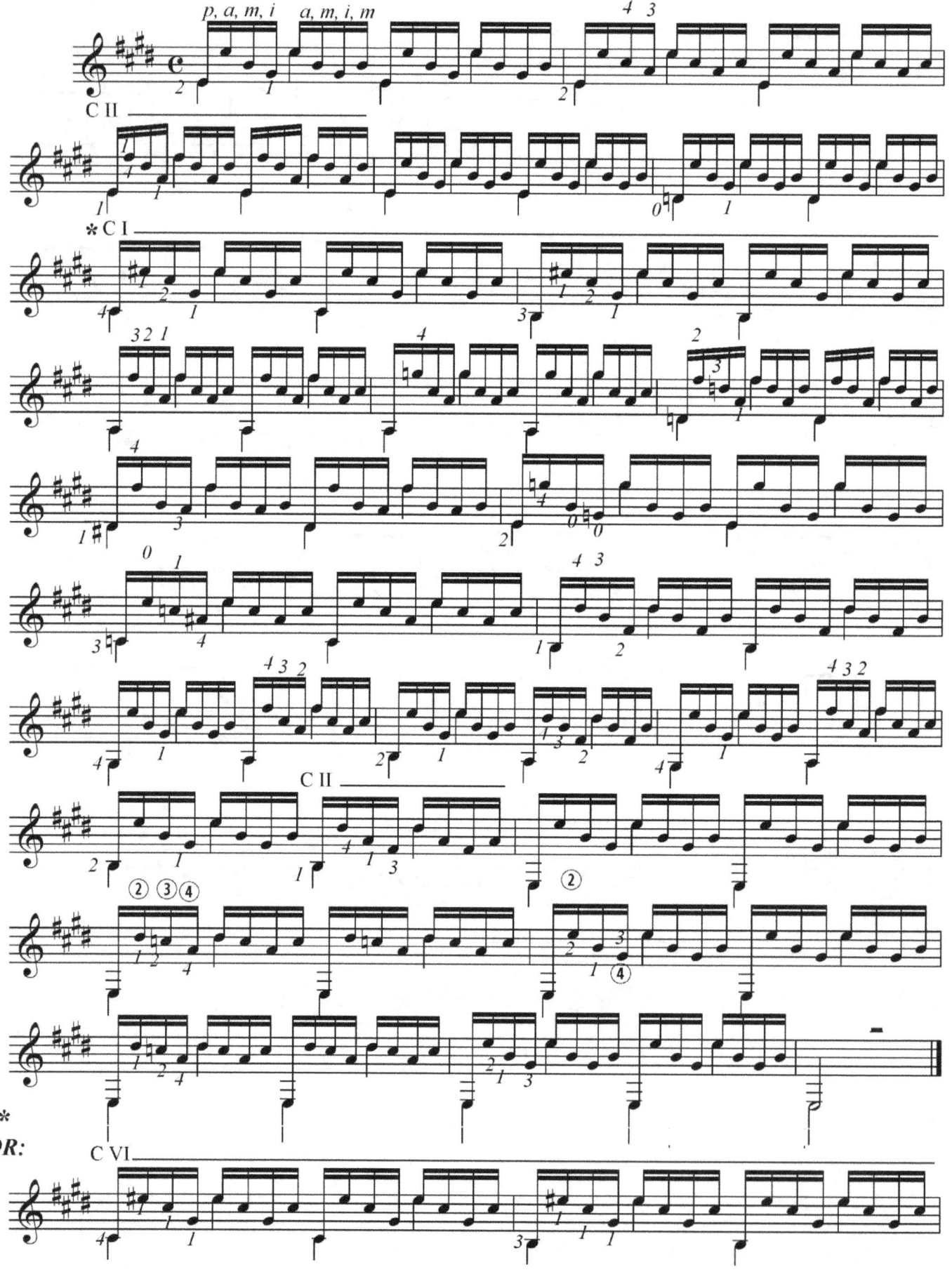

Prelude No. 12

Right hand fingering: p, m, i and p, a, m

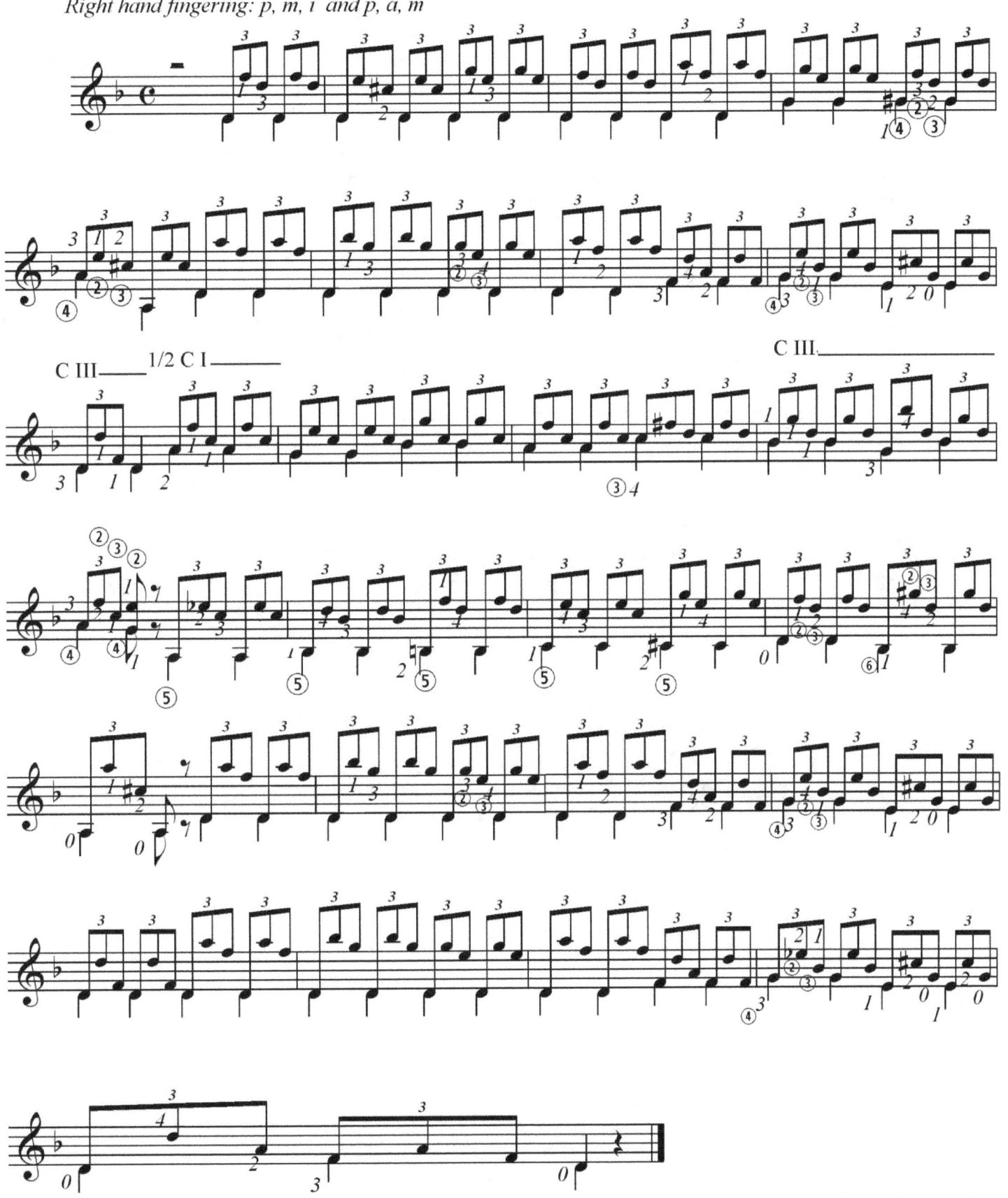

In an old and often used version, the editor has indicated that the first finger should barré the fourth and third strings at the second fret while the second finger frets the second string at the second fret producing an A major chord in second inversion. This *mini-barré* forces the first finger knuckle into an awkward reverse bend. It also ensures that the first finger will have to release and reposition to execute the G# on the first fret of the third string in the following measure. The measure prior to the example presents no need for the fingering indicted in the first measure of the sample. Therefore I believe it is a more productive use of the left hand to finger the measure as indicated in the first measure of the second line of the example. By eliminating the barré and using three fingers that will *not* be required in the following measure, the first finger is already 'hovering' over the note it will be required to fret in the following measure. When the time comes to transition between the hand shapes at the bar line, the three fingers in use can be removed simultaneously with the first finger moving in to fret the G#.

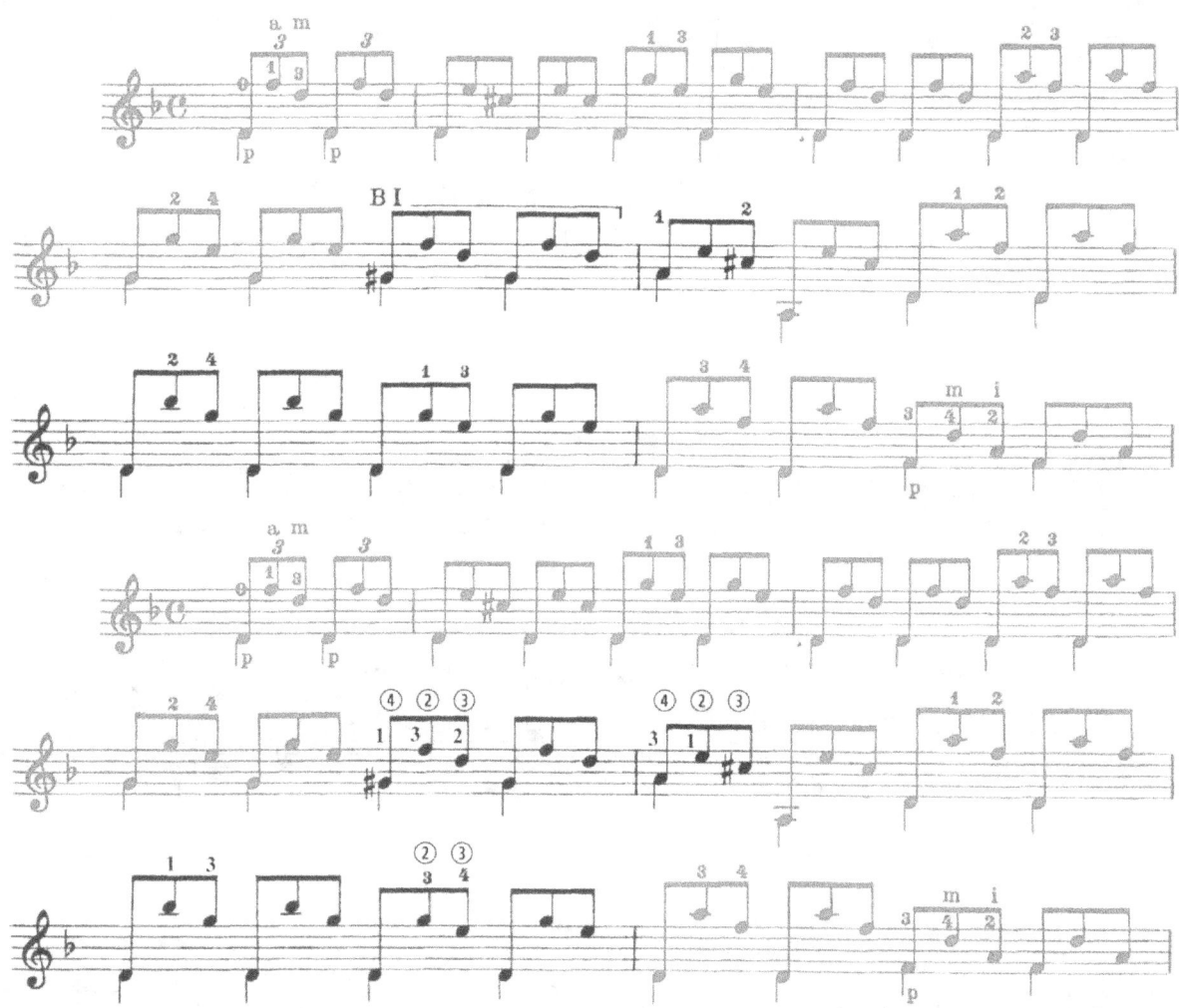

Prelude No. 13

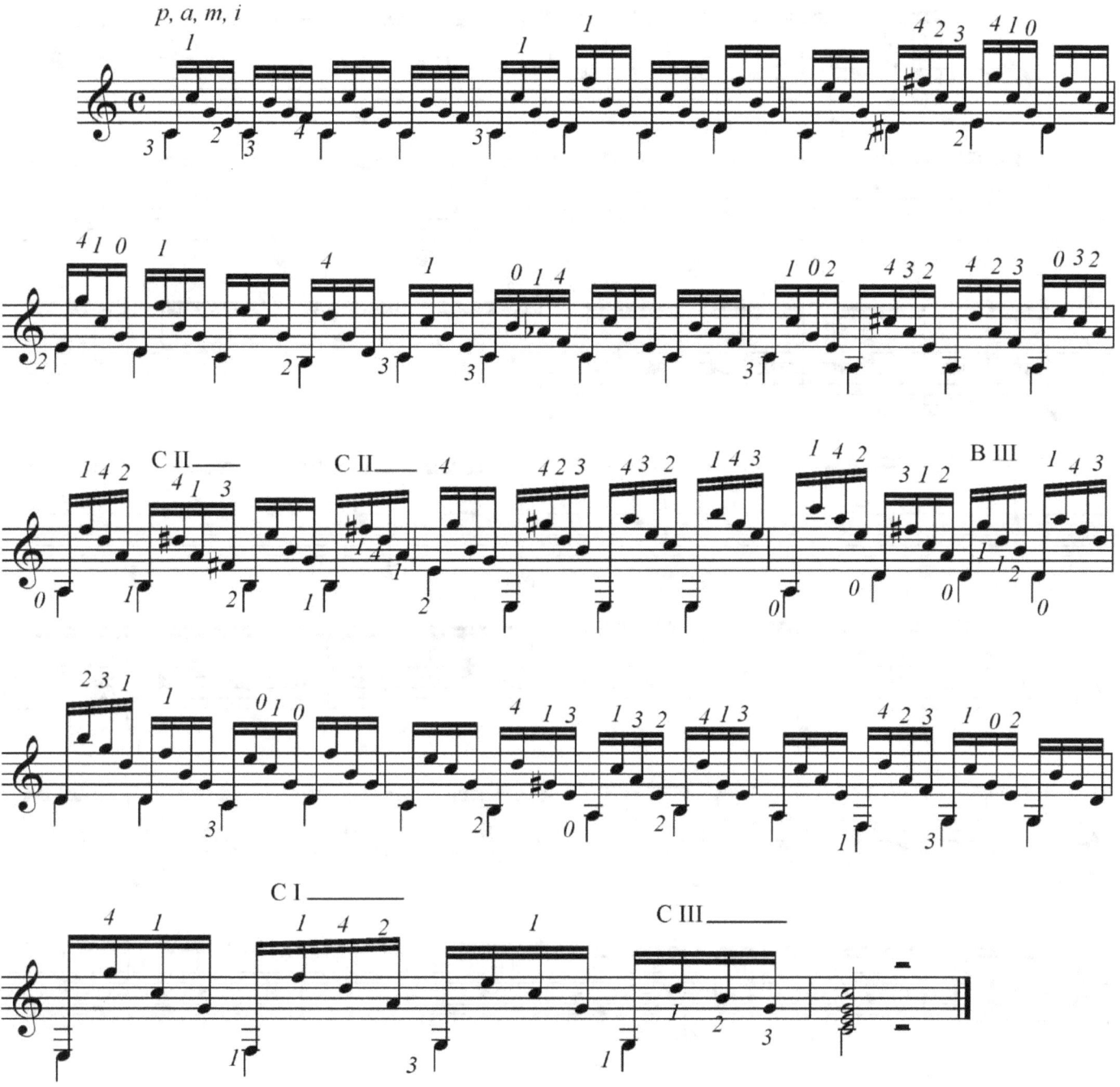

Prelude No. 14

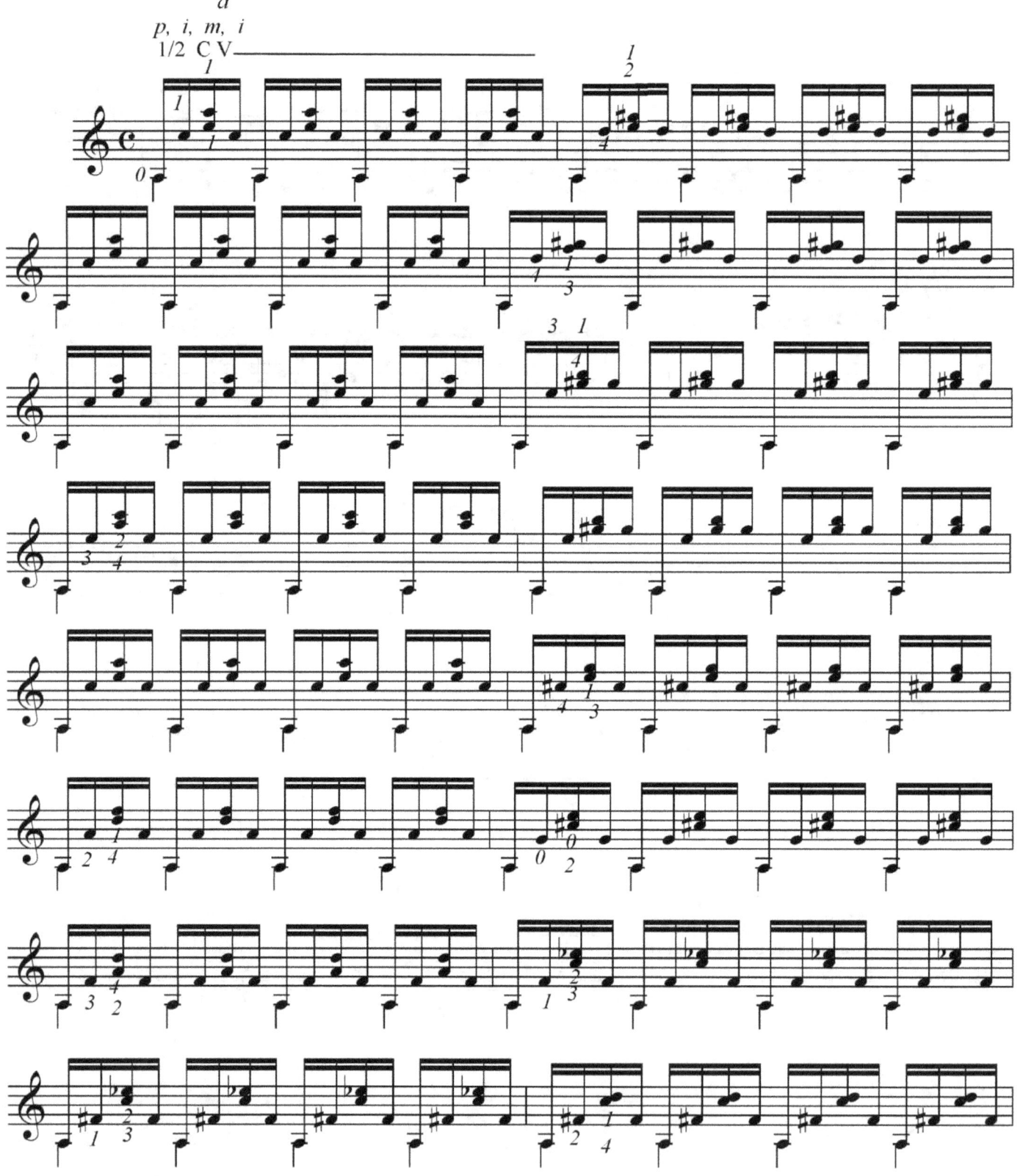

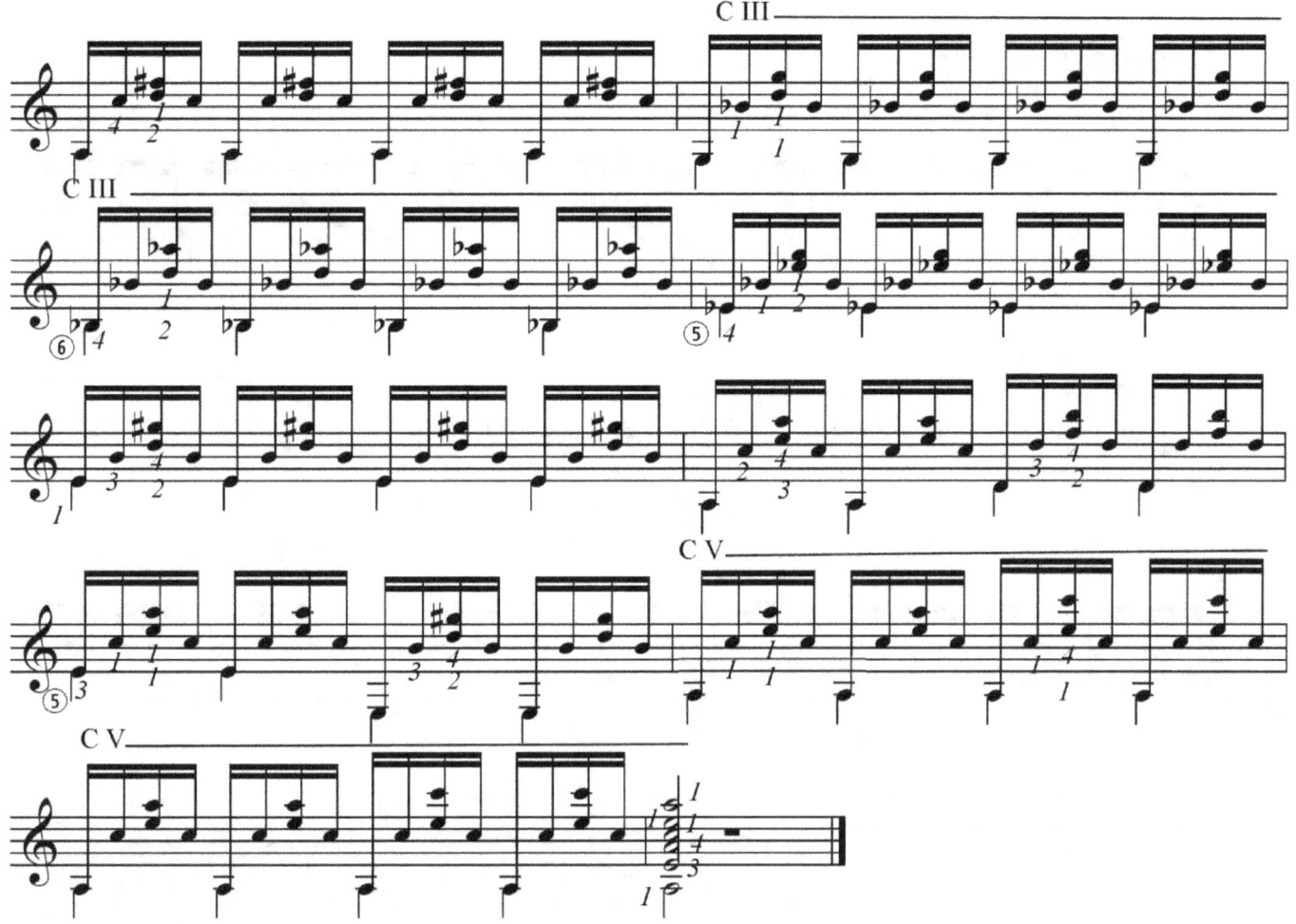

This prelude can be described as just a bit monotonous. The right hand is exceedingly repetitive and not particularly inspiring. One suggestion is to play the prelude halving the number of repetitions of each chord/hand shape. In other words, in measures where the pattern is repeated four times, play it twice. When there is a change on beat three, only play beats one and three. The student and/or the teacher should feel free to substitute a different right hand pattern—possibly one with which the student has had difficulty. In short, don't be afraid to modify to suit!

Prelude No. 15

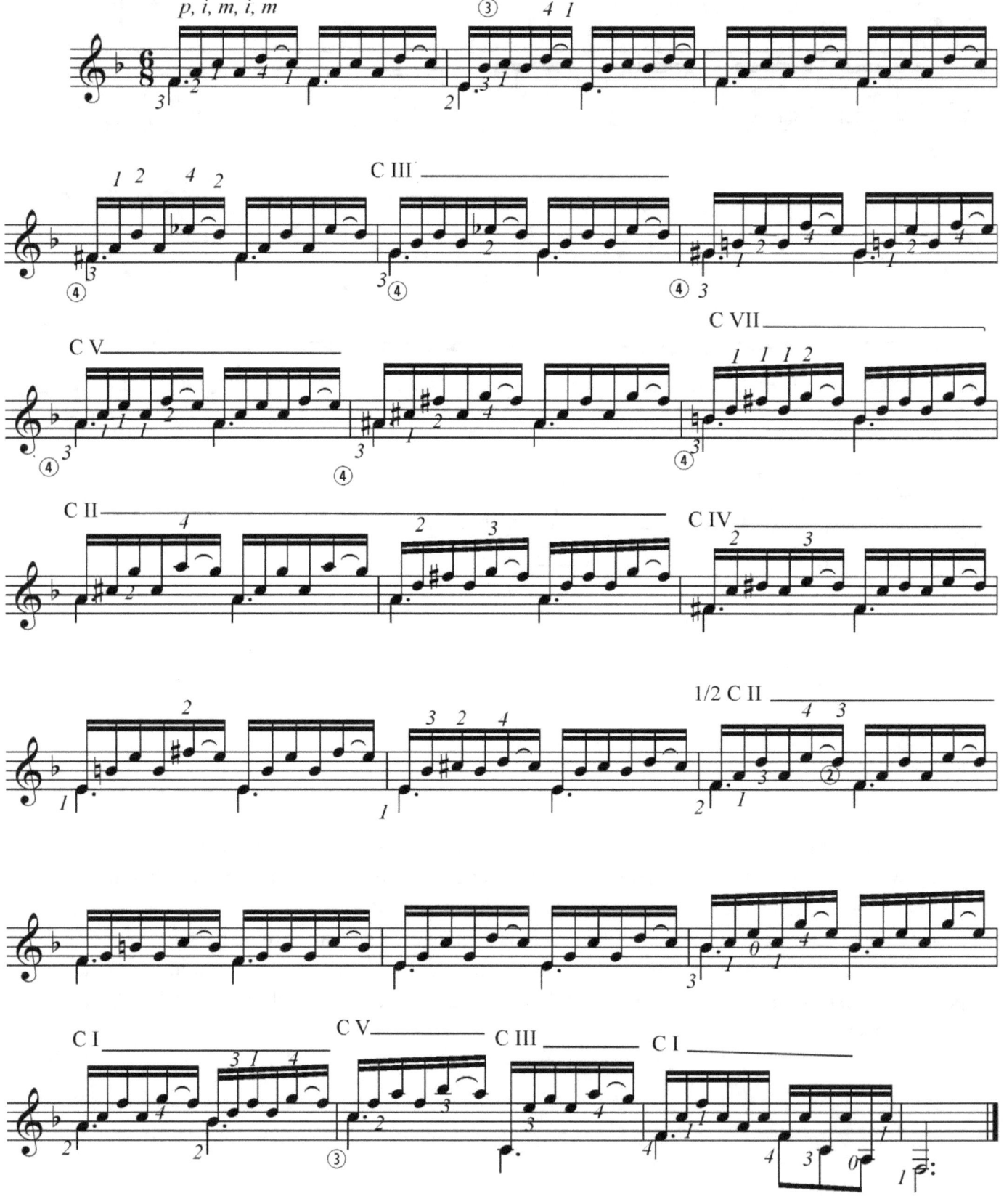

Prelude No. 16

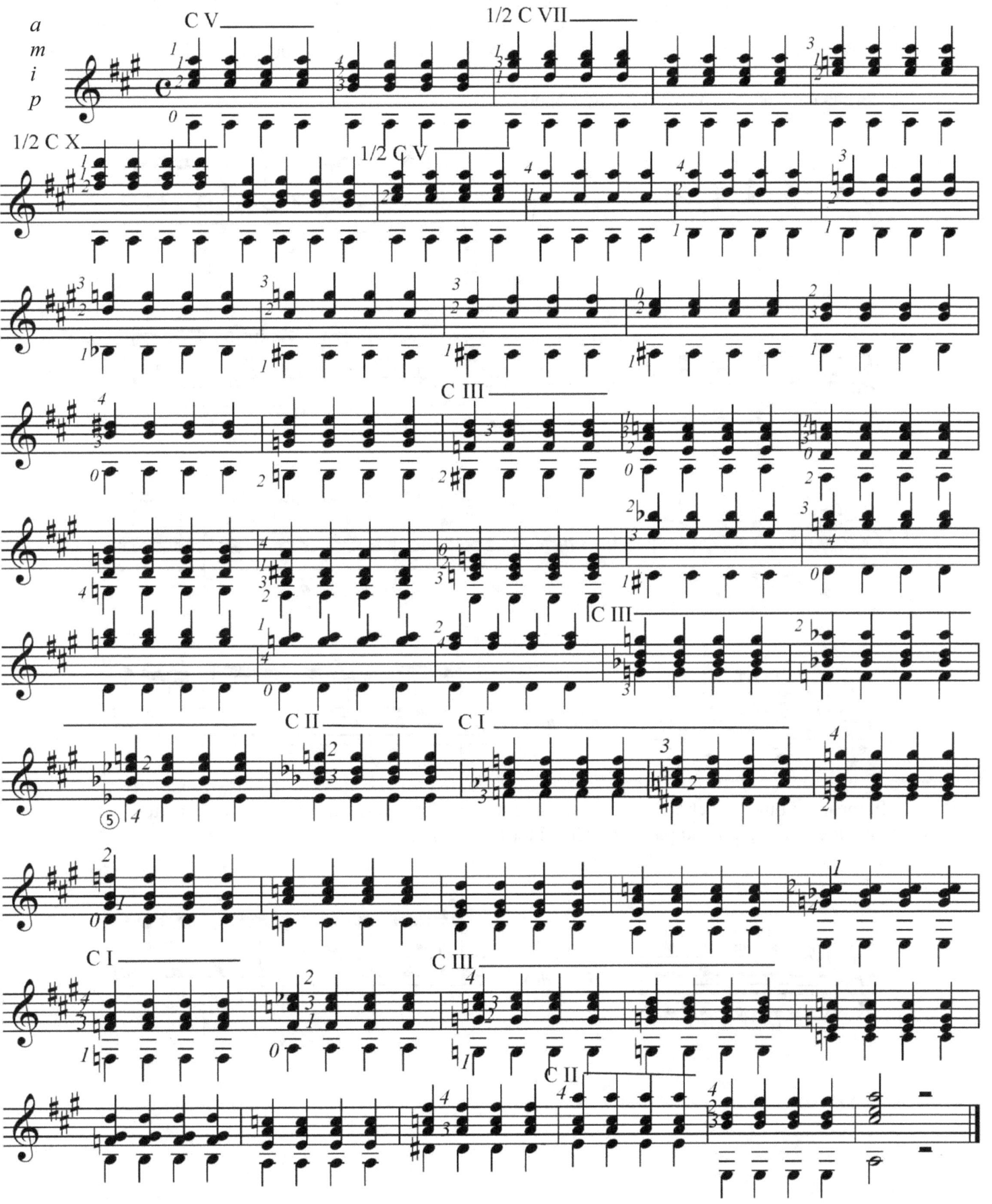

Prelude 16 has interesting harmonic content, however aside from pedagogical interest; the right hand is quite uninspiring for the student. Once the block form as presented in the original prelude is mastered, some alternate right hand patterns may be used for further practice.

Here is measure one in various right hand permutations.

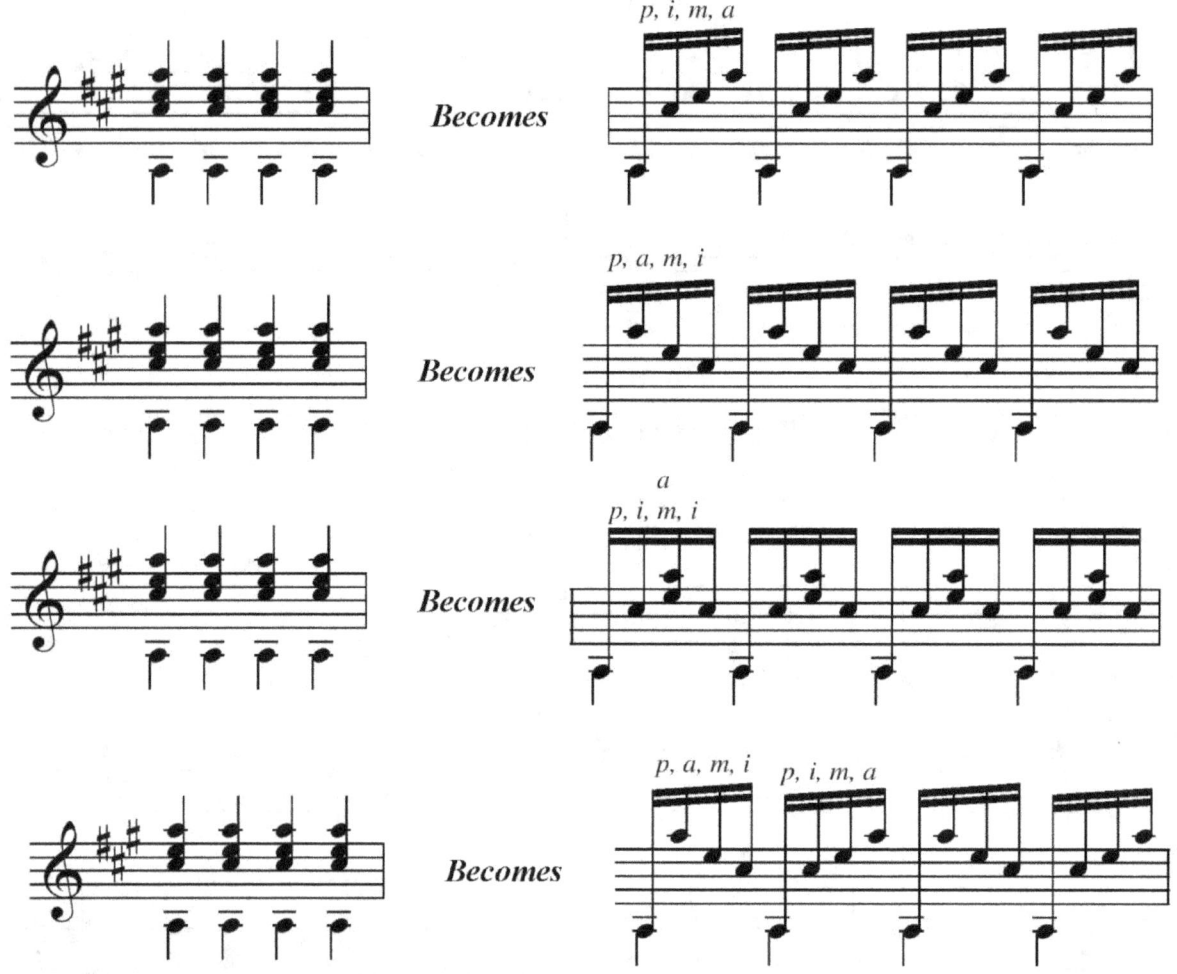

In measure nine, the chords lose a note and this may throw off the student who is attempting to create alternate right hand patterns. Consider the following example for that measure.

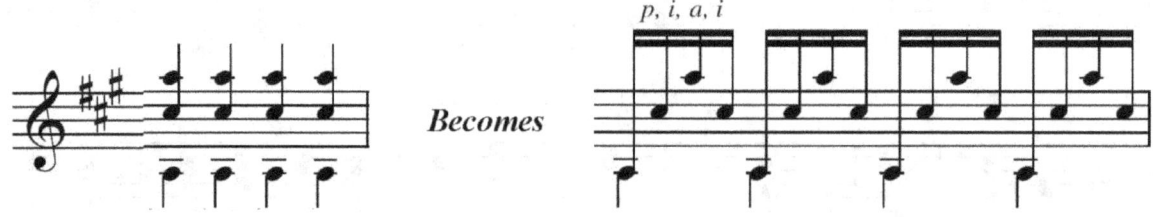

PAGE INTENTIONALLY LEFT BLANK

Prelude No. 17

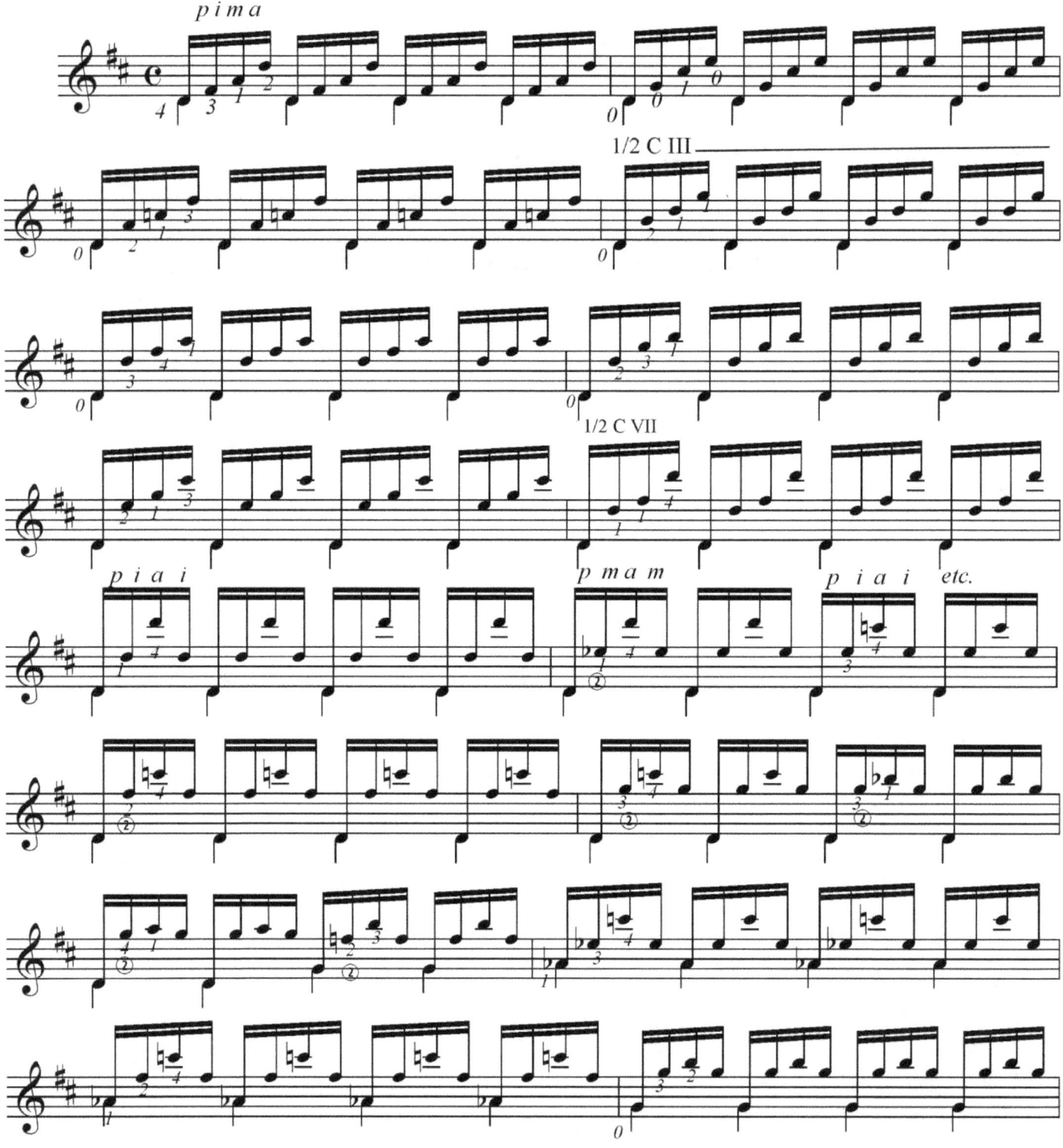

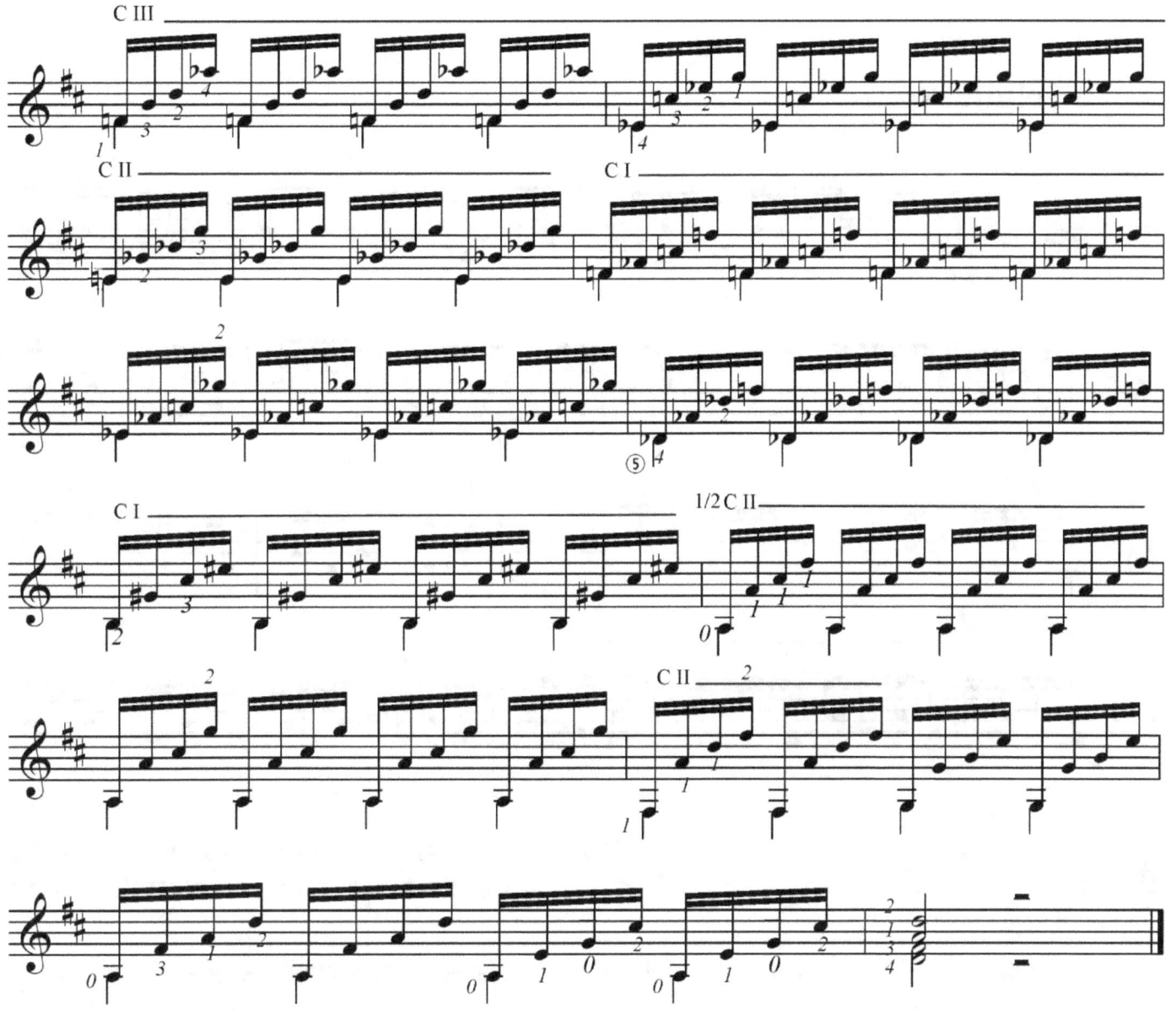

- Note right hand fingering in measures 9 through 16. Where non-adjacent strings are being plucked (as in measure 9), non-adjacent fingers are used. This maintains correct had geometry and eliminates stretched between right hand fingers. When plucked notes return to adjacent strings, it is performer's choice whether to use **i** and ***m*** or ***m*** and ***a***.

Prelude No. 18

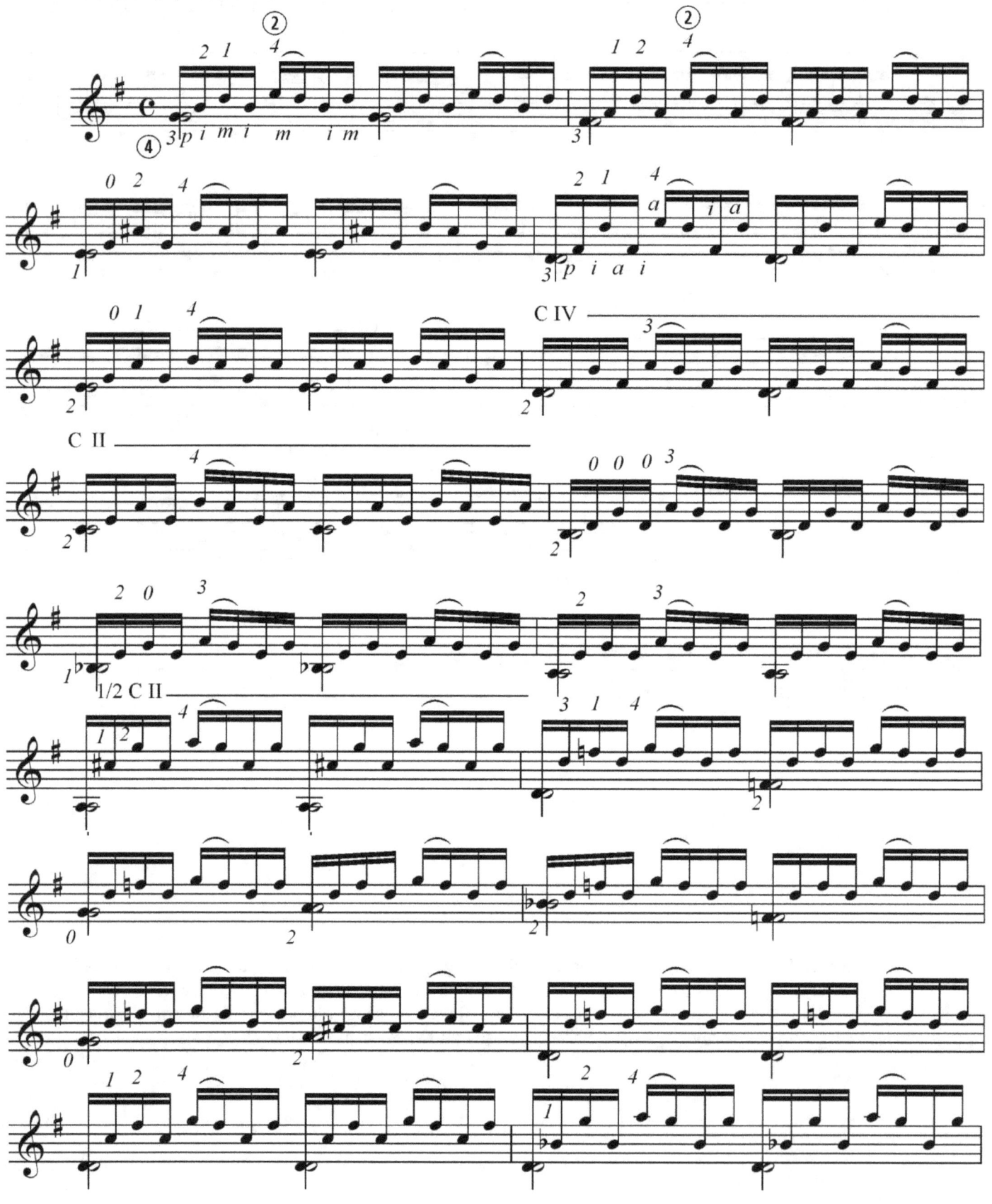

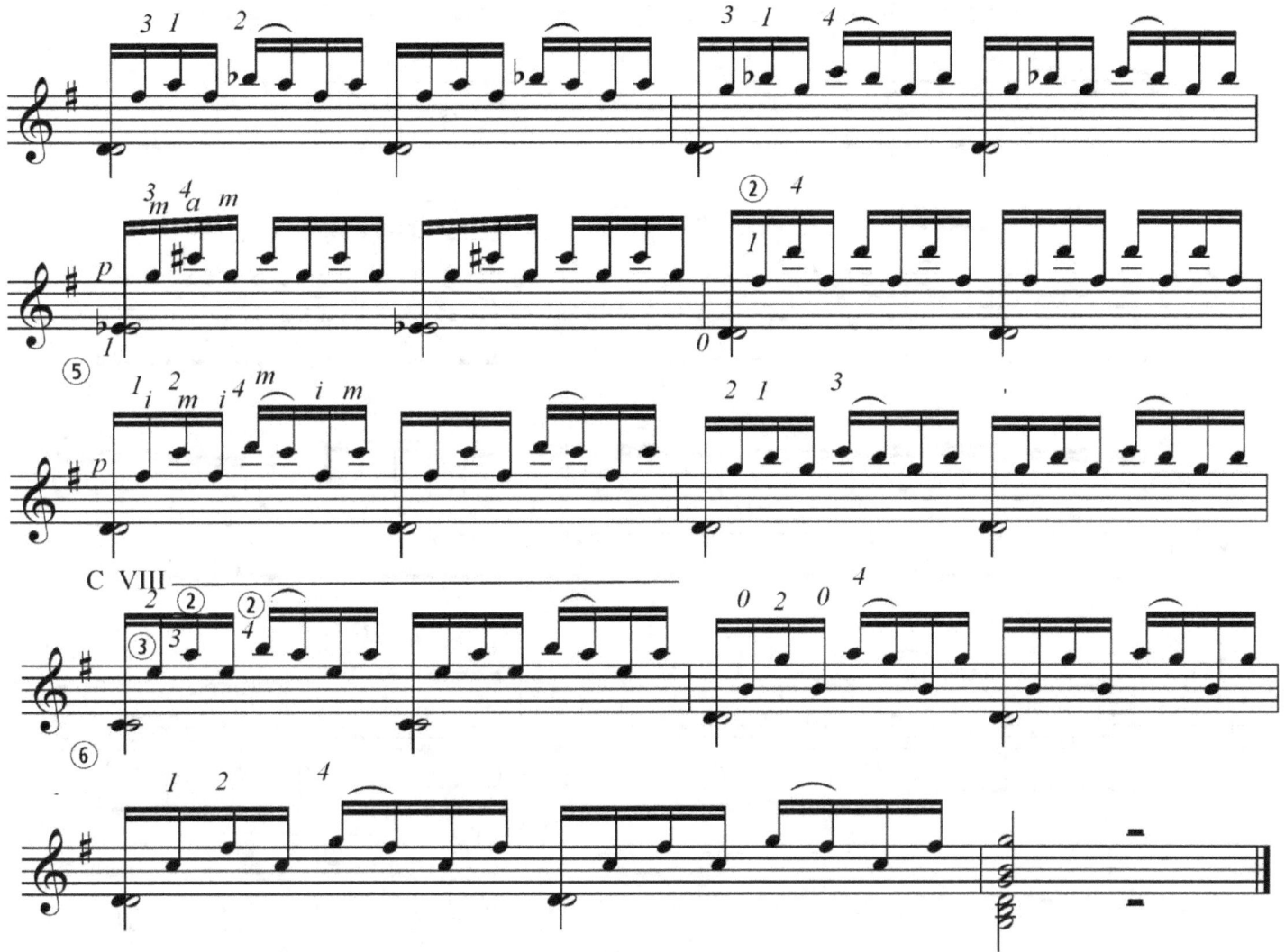

Notes on Prelude 19

From Prelude 19 on, the difficulty level of the pieces increases at a rate that will slightly befuddle the student. In fact the student may decide to either shelve the preludes or skip ahead to see if the situation changes (which it does by Prelude 21.) Actually, some insist that Prelude 24 is arguably one of the easier pieces in this Opus. Prelude 19 contains some difficult left hand chord shapes with equally difficult slurs to be executed within them. The student guitarist should look upon these with the stoic attitude *that which does not kill me makes me stronger*. Seriously, the student should not seek to neglect the more difficult preludes.

Prelude No. 19

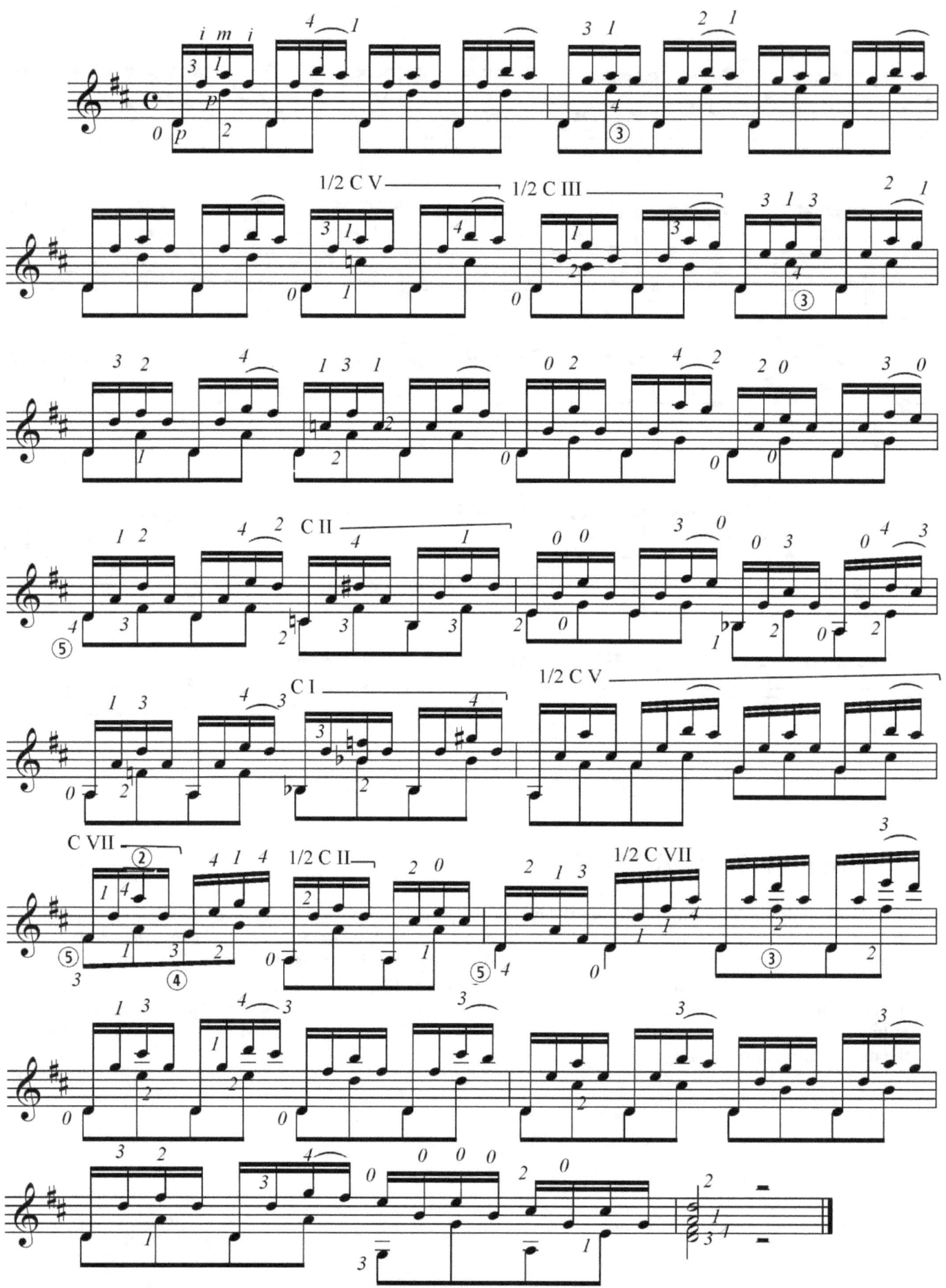

PAGE INTENTIONALLY LEFT BLANK

Prelude No. 20

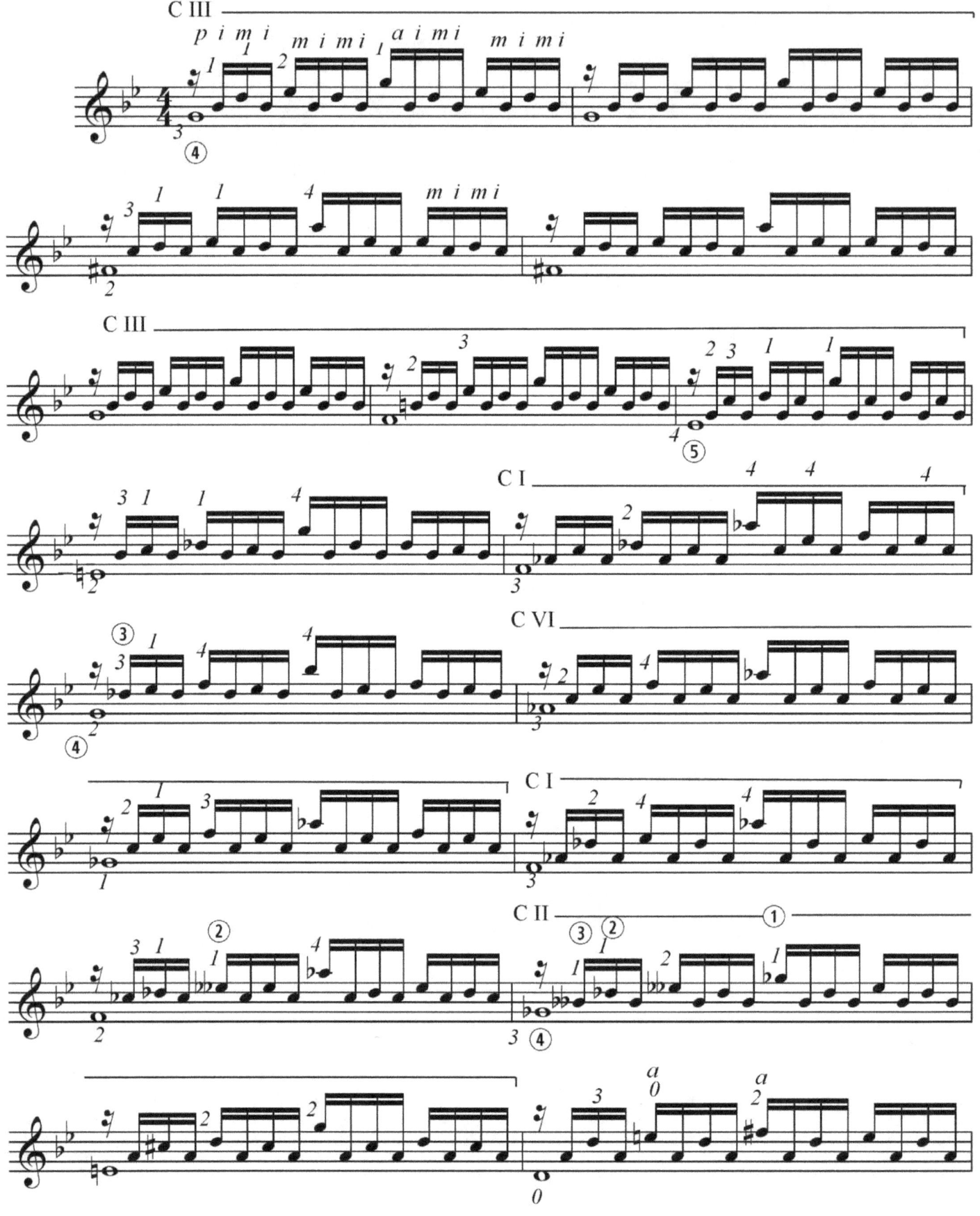

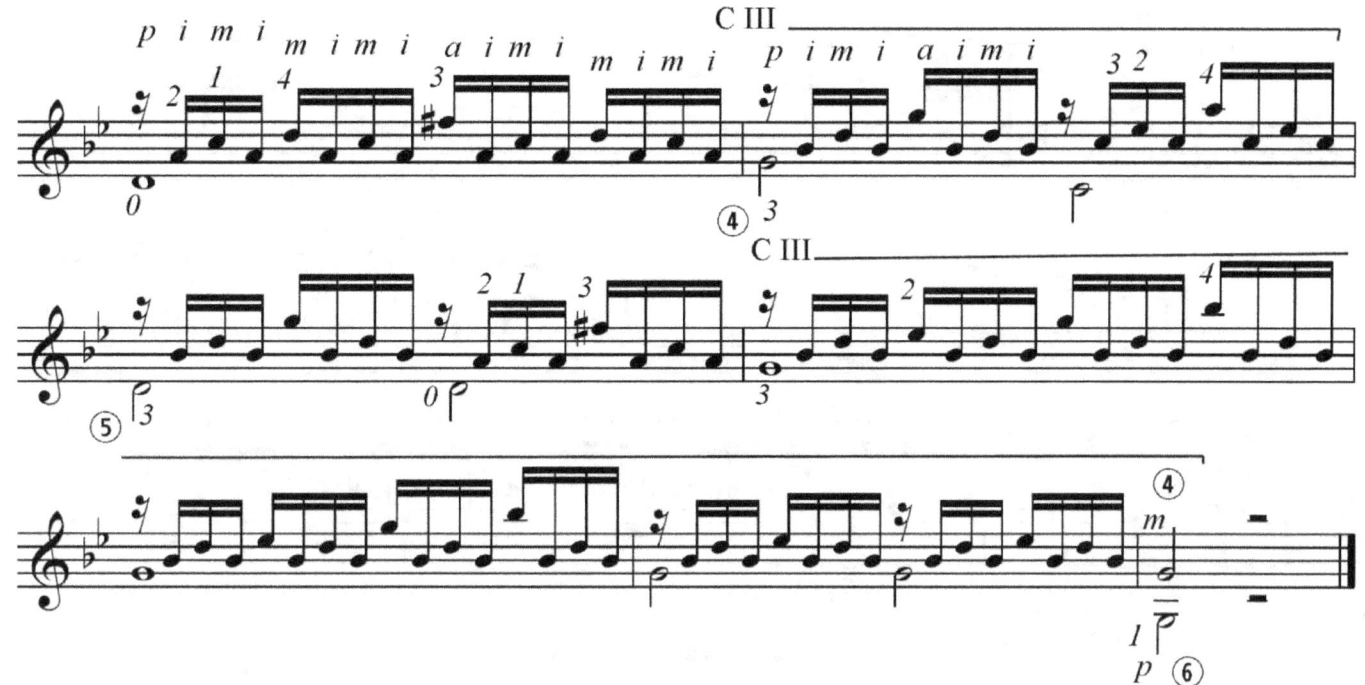

Prelude No. 21

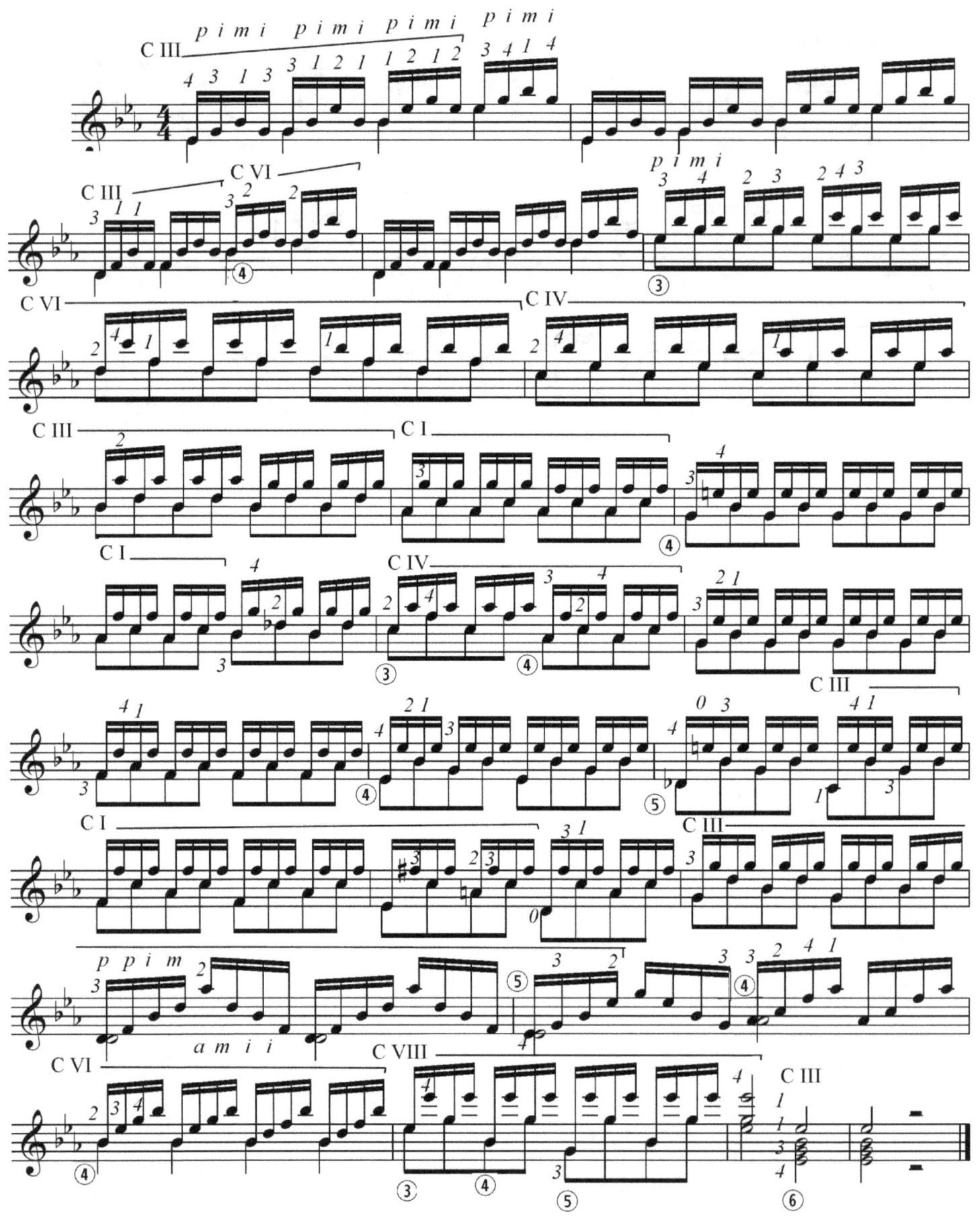

PAGE INTENTIONALLY LEFT BLANK

Prelude No. 22

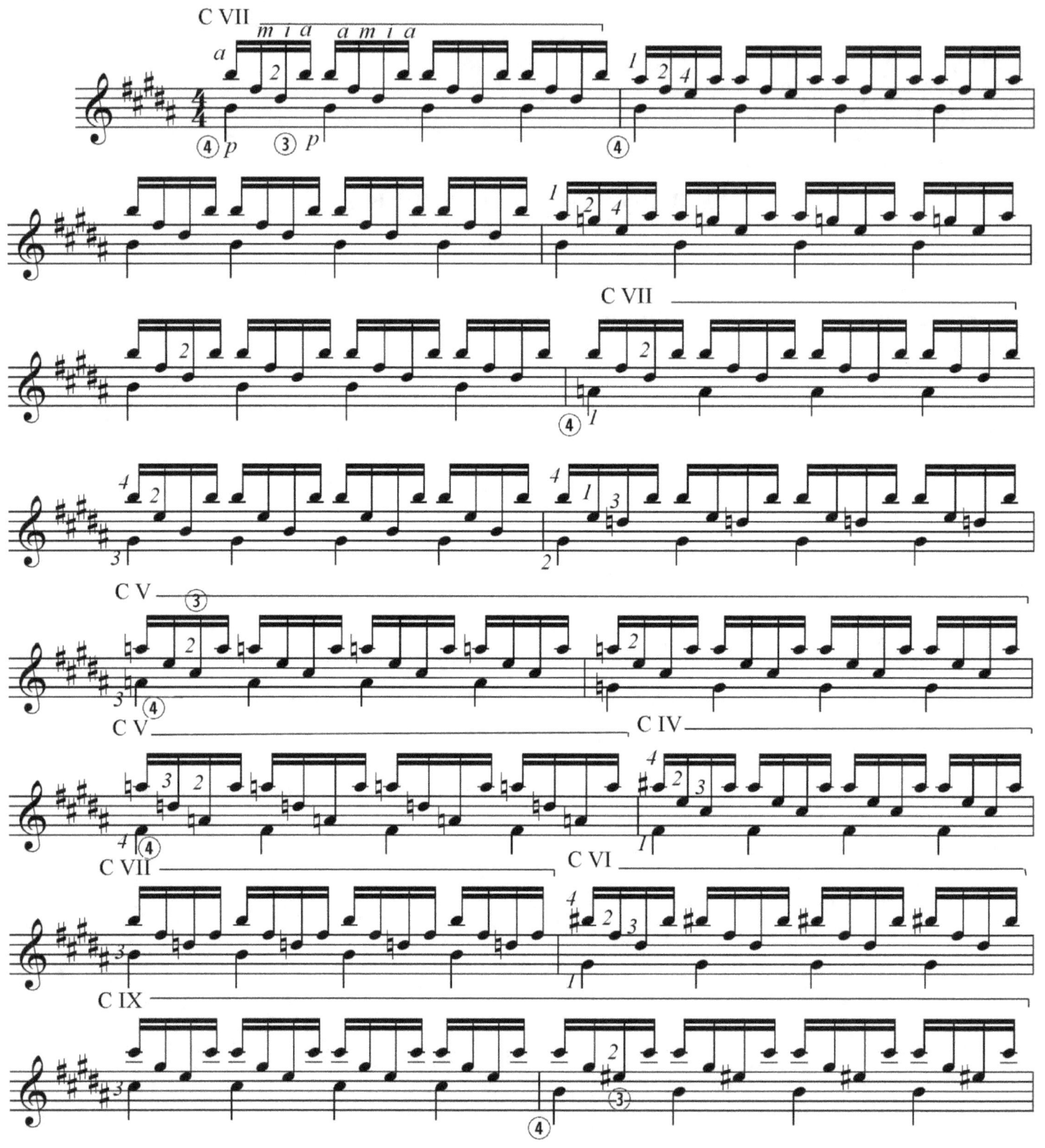

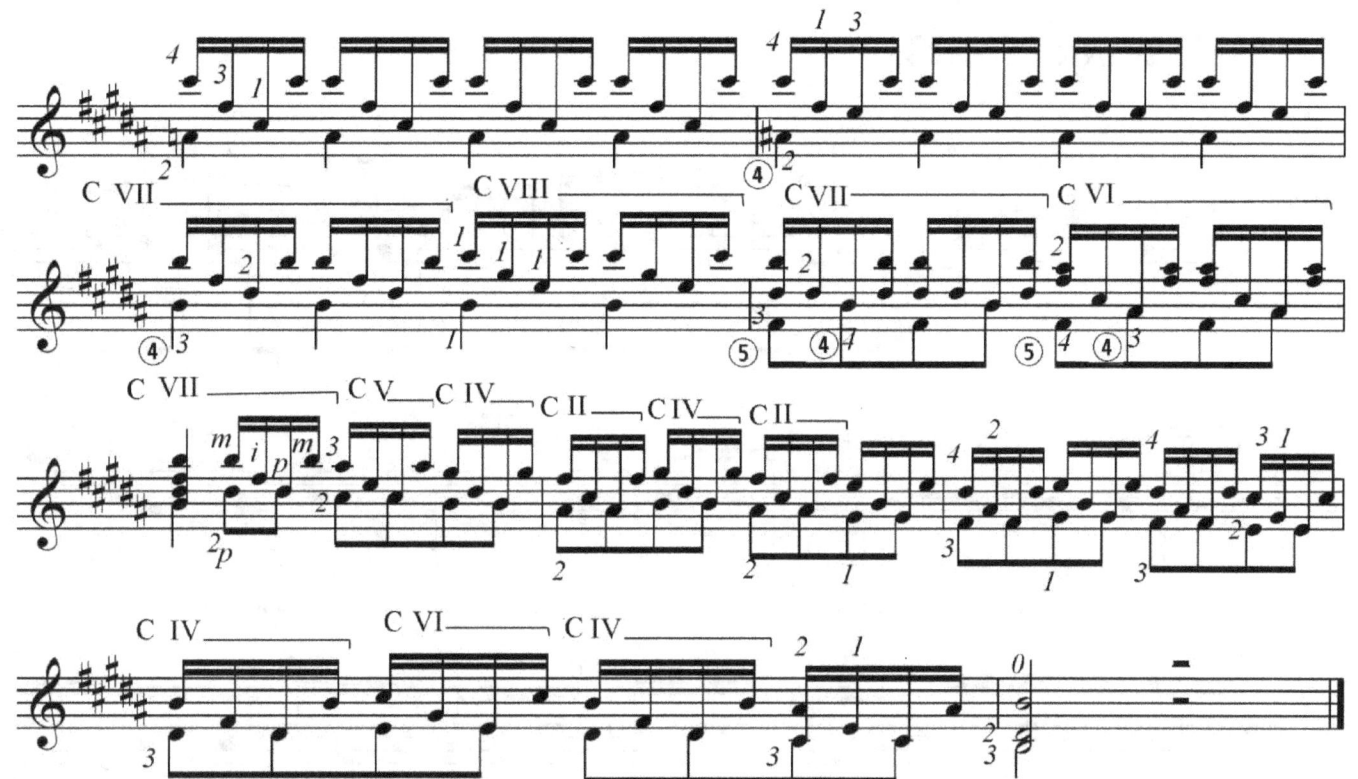

Prelude No. 23

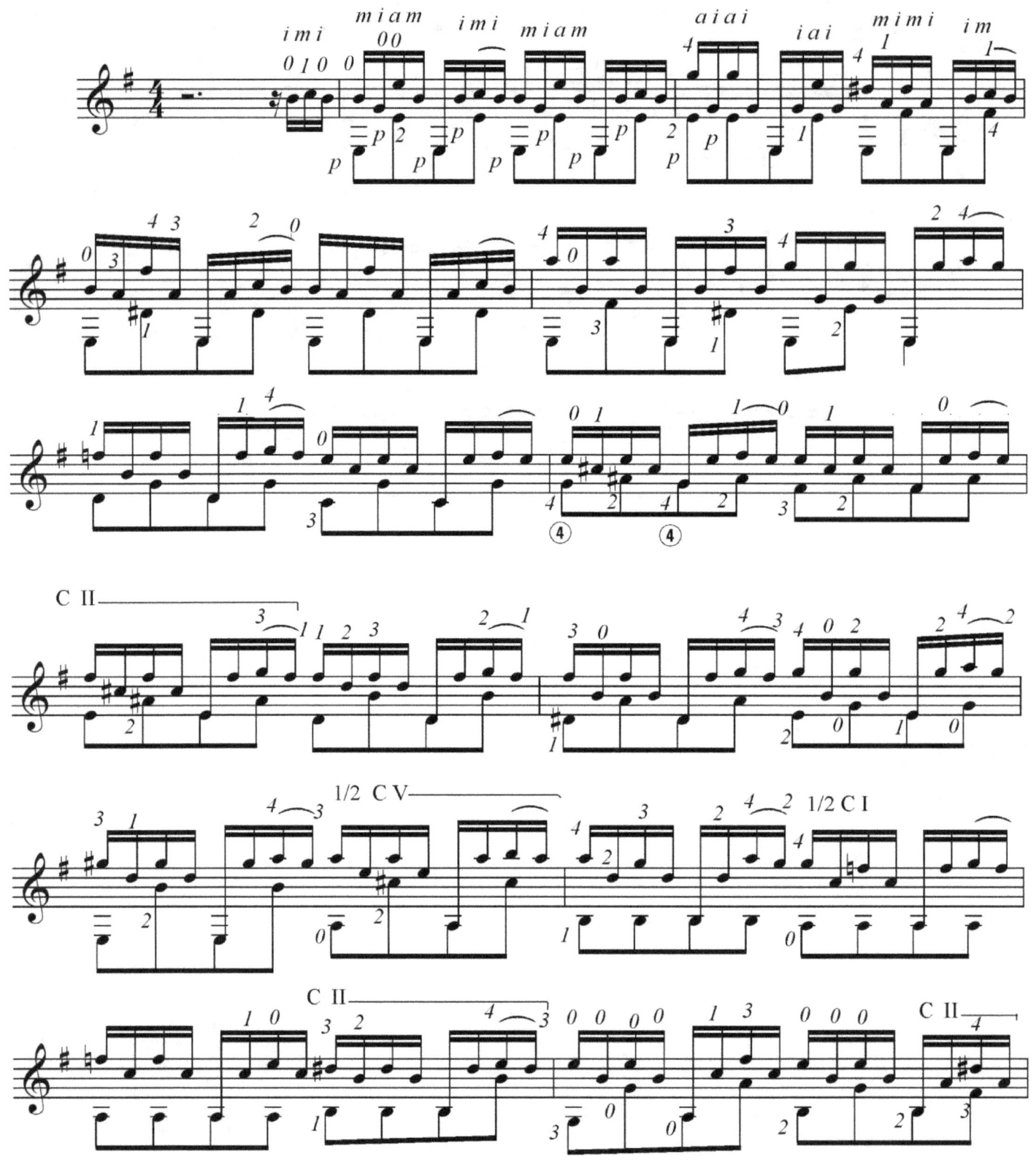

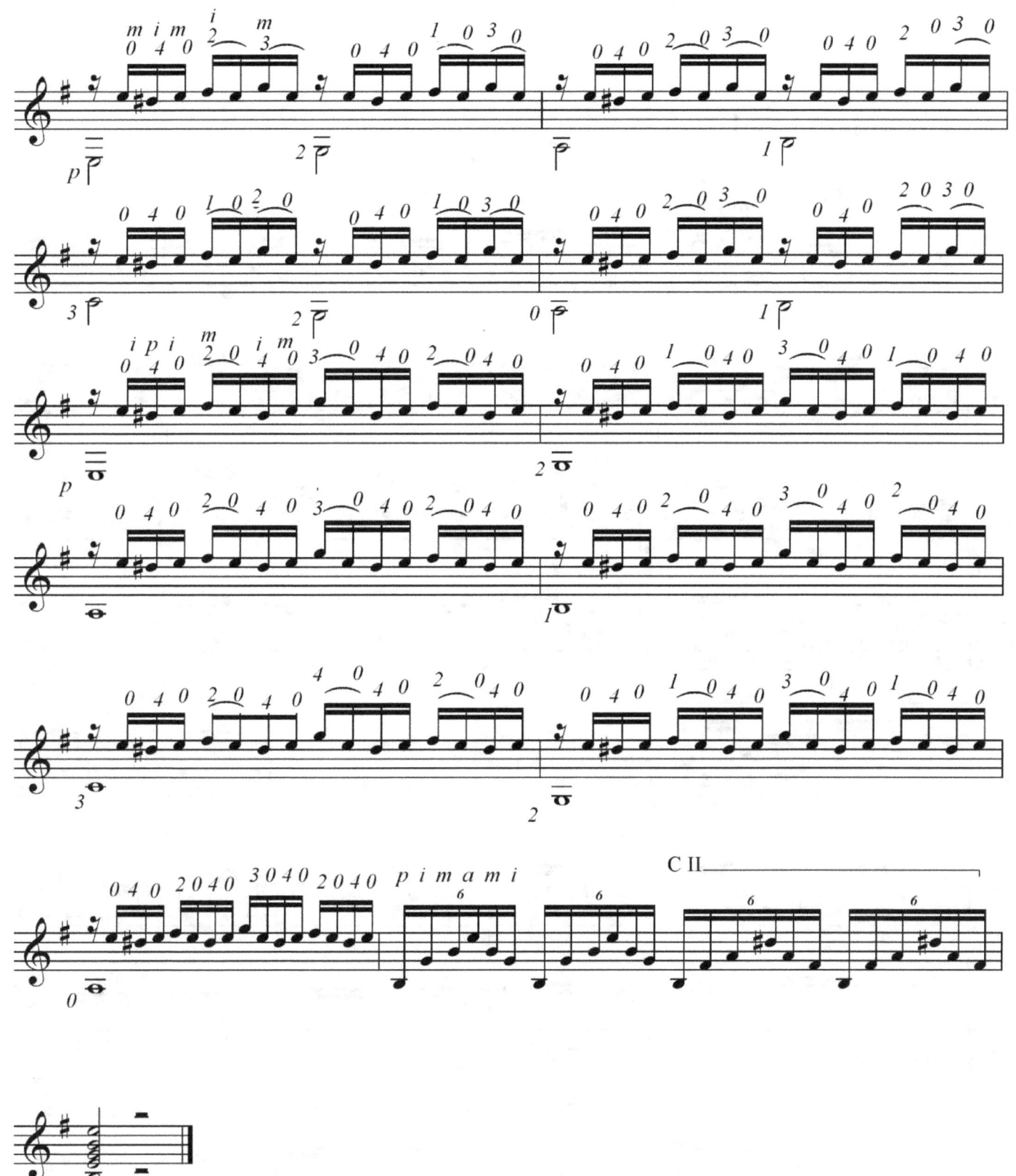

Prelude No. 24

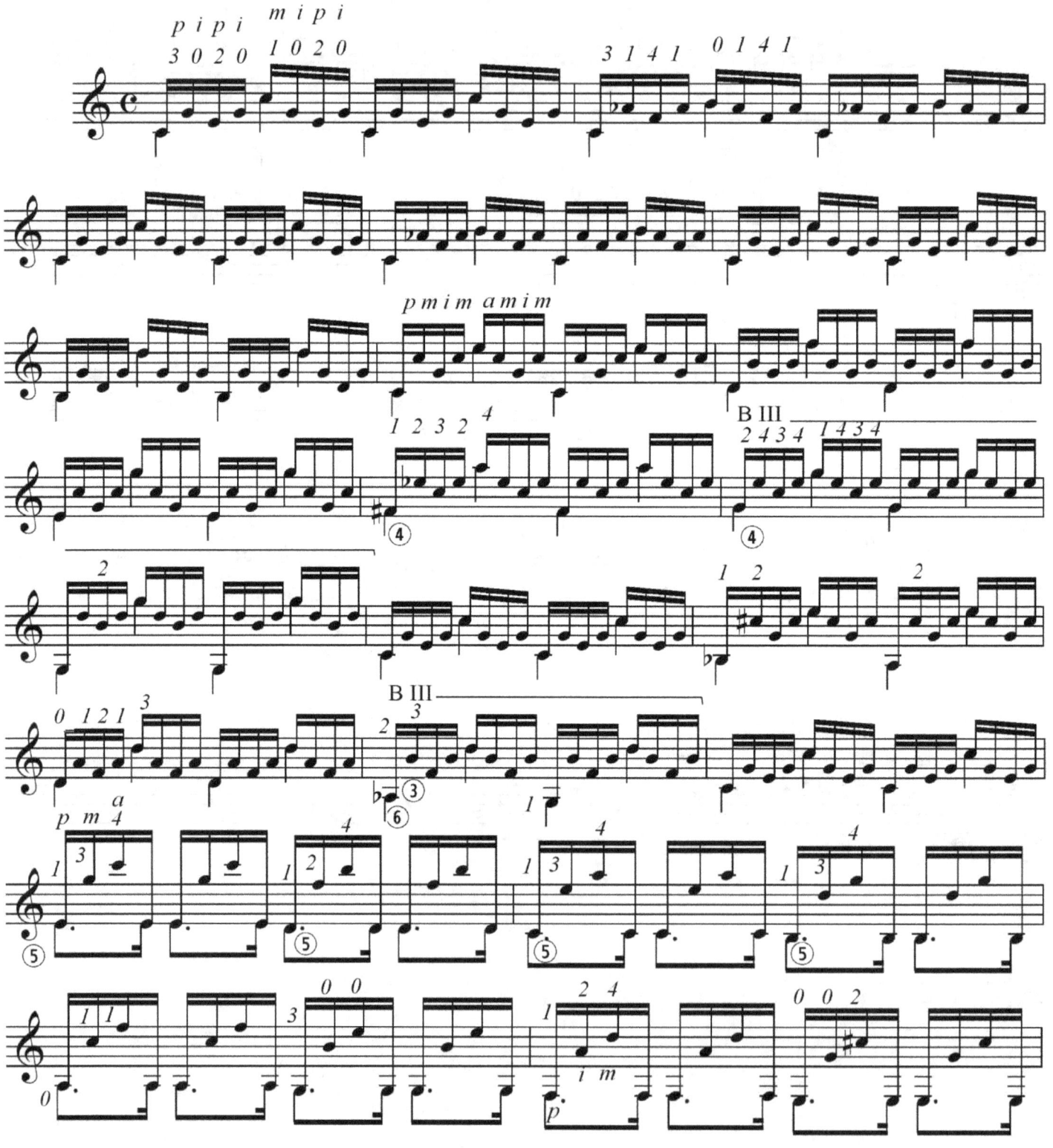

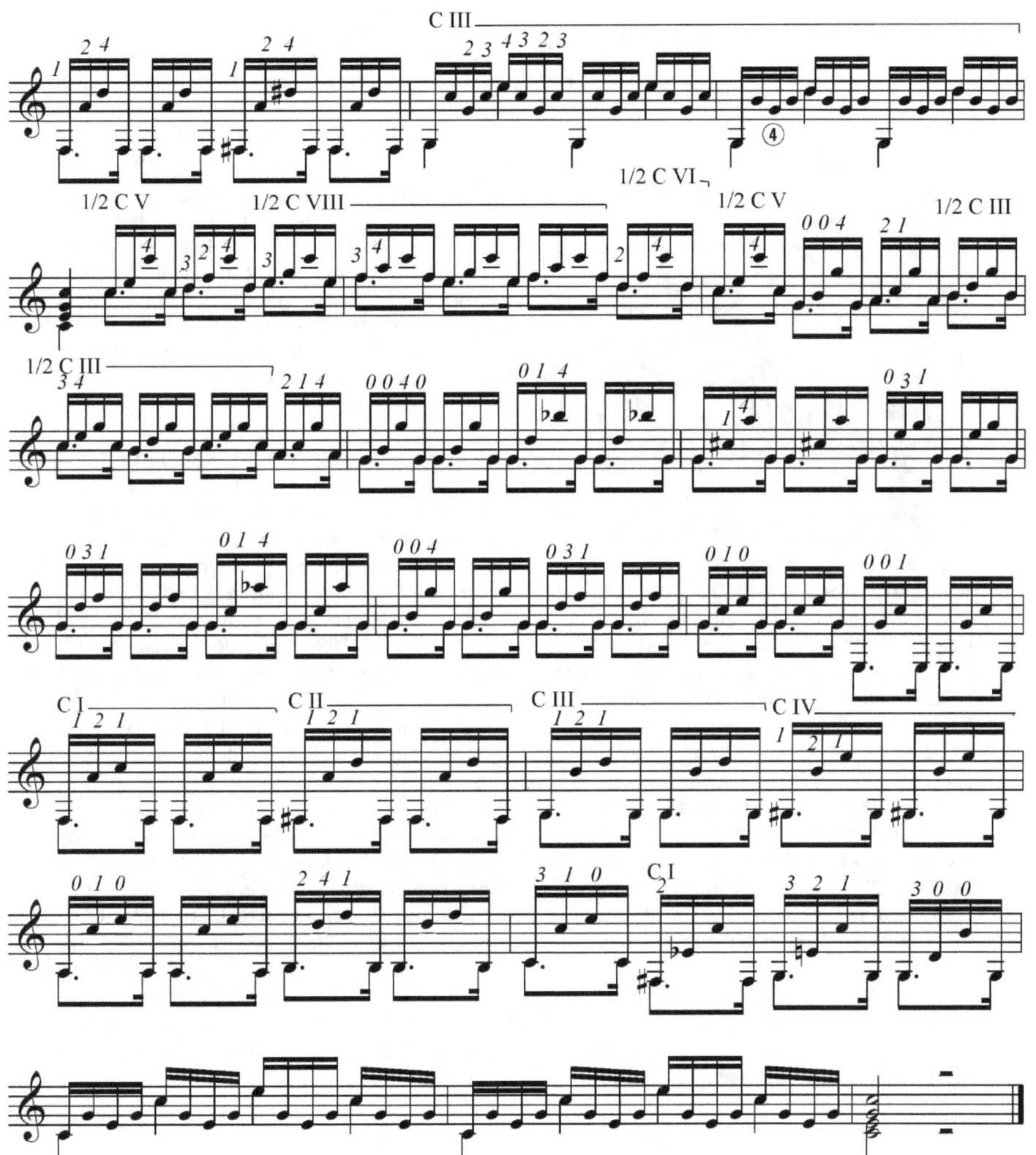

Note: Sequential left hand fingering in measures 26 through 29 and measure 35.

Harry George Pellegrin was born February 4, 1957 in Bronxville, New York, United States.

Musician, writer, photographer, and graphic artist. The only child of Harry Pellegrin (1902-1981) and Veronica M. Pellegrin (1918-2004), Harry G. Pellegrin attended Mount Saint Michael Academy in the Bronx, graduating in 1974. Pellegrin studied piano as a small child but became interested in the guitar in 1970 and by 1973 was performing. Pellegrin attended Bronx Community College from 1974 to 1976. He majored in classical guitar at The Mannes College of Music in Manhattan, studying with Albert Valdés-Blain and Eliot Fisk.

A severe traffic accident in 1989 resulting in fractured thoracic and lumbar vertebrae with some permanent damage to the spine and the associated neurological deficits curtailed his musical career for almost seven years and channeled his energies towards his other interests, writing and photography. Pellegrin wrote for *Soundboard, The Journal of the Guitar Foundation of America* and *Ironhorse Magazine* before publishing his first novel *Low End*, in 2003. The first of a series, *Low End* (ISBN 1589820746) was followed by *Deep End* (ISBN 1435721985) in 2006. *Classic Guitar Method, A Comprehensive Method designed to transform the student from novice to recitalist* (ISBN 978-0-557-26825-2) combined Pellegrin's writing skills with his musical expertise. Pellegrin performed his come-back recital at the Troy Savings Bank Music Hall in Troy, New York on February 13, 2007, his first classical performance since the 1989 accident.

In May 2008 PAB Entertainment Group released *The Guitar* (700261240428) a CD of solo classical guitar music performed by Mr. Pellegrin which includes a number of compositions by the performer. In 2010 PAB released his second album of solo classical guitar *Old and New* (885767622234) which includes favorites of his from a number of stylistic periods. Pellegrin also composed and recorded a series of four brief waltzes for this CD, two of which are dedicated to his parents and celebrate their lives and chronicle his sense of loss at their deaths.

Now residing in Northern New York State with his wife and daughter, Pellegrin performs, teaches and writes. Since January 2008 he has been a member of the adjunct faculty of Union College in Schenectady, New York. He was installed as a member of the Board of Directors of the CGSUNY for calendar year 2012 and is an artist member of the Monday Musical Club of Albany.

Now in one volume, much of what the novice classical guitarist will need to know to lead him or her to the recital stage. From proper instrument care and maintenance to the necessary technical skills, musical mind-set, and the standard repertoire—all are exposed and explored with enough detail and insight that the student will wish to keep this book handy years to come as a ready reference source. With the aid of a good teacher, the student will rapidly progress through Classic Guitar Method attaining technical proficiency and musical eloquence. A number of studies by Sor, Giuliani, Coste, Carulli and Carcassi are expanded and graded. Examples from the standard repertoire reinforce the techniques highlighted in the studies.

ISBN: 978-1-4116-9442-2

Folio For Guitar is a collection of pieces for solo classical guitar that include four Vals Brevis (Brief Waltzes) as well as three tone poems: Elaine, Nacht Tanz and Snowfall: 12.28.2008. All pieces written by recitalist and composer Harry George Pellegrin. Difficulty level: intermediate to difficult.

The 120 Right hand Studies of Mauro Giuliani, edited and annotated by Harry George Pellegrin. These landmark instructional studies/warm-up exercises have been overlooked by many pedagogues over the past two or three decades. It is time to rediscover their benefits. Includes a new edition of the works as well as a facsimile of the Artaria second edition. Included is a systematic examination of how the exercises are structured and how they should be practiced. A must-have for the classical guitarist's library.

ISBN 9781105953071

Even if the guitarist knows what notes must be played and where to find them on the fingerboard, there remains what fingering works well for each passage—but will this fingering allow the player to move with accurate efficiency? The fret board does have an easily recognizable arrangement of half steps and once that truly is understood, the fret board becomes almost as graphically representative as the piano keyboard. This text focuses on this underlying principle and develops it into a system encompassing the horizontal as well as vertical methods of learning the fingerboard and how these two conceptual disciplines are interrelated. The diligent student finds insight into why editors and performers have varying opinions regarding the fingering of identical pieces. Opinions-and fingerings-are not engraved in stone. Some editors finger music to ease performance, some for tone considerations. In some cases there may be only one way to finger a passage.

ISBN 9781304947895

Music: Is it a hobby? Is it a pastime? Is it an ego boost? Is it an obsession? Only if it is an all-consuming obsession should one consider music as a career. Someone once said "If anything can discourage you from being a musician, let it!" Seduced by the Muse is the biography of a professional musician highlighting how life's experiences--death, injury, sickness, ridicule and praise--shaped a relatively successful career. Music is life to the musician and every incident, emotion and trial form the core of how that musician interprets his world and this interpretation is clearly apparent in every note played. The observations of classical guitarist Harry George Pellegrin.

ISBN 9781312031951

Low End is an exciting new novel dealing with modern issues in the style of the classic 1940's mystery writers. Low End is murder mystery with a twist involving a least-likely detective, a disillusioned, New York City musician named Gary Morrissey. Gary finds himself involved in a murder investigation of his own making when shadows of government corruption and hints of premeditated genocide are cast over a friend's murder. The author's own experiences are reflected in his lead character, whose love for New York City and for its less-than-attractive suburbs and citizens emanates from every page and whose musical knowledge and expertise provide a unique background for the events that unfold. Some mild language and violence, no sex.

ISBN: 978-1-4357-2198-2

Helen is the kind of girl you dream about. She's smart and confident, funny and affectionate, and she's killer good-looking. Gary has fallen for her, and fallen hard. Even so, he is still distracted by life's little happenstances. It's those minor things like, oh, crooked cops, shady club owners, drug smuggling, and a few dead bodies. Still, Gary can't keep his eyes off Helen. Harry Pellegrin's mystery novel DEEP END is packed with eerily real sinister characters, music, interesting locales, bizarre spirituality and a plethora of corpses. Couple this with an exceedingly clever plot and we have this year's best beach-read. Serial killings and alternative spirituality discussed. Some violence, no profanity, no sex.

ISBN: 1589820746

www.ingramcontent.com/pod-product-compliance
Lightning Source LLC
Chambersburg PA
CBHW080849170526
45158CB00009B/2688